Family

Photographers photograph their families

Phaidon Press Limited
Regent's Wharf
All Saints Street
London N1 9PA

Phaidon Press Inc
180 Varick Street
New York, NY 10014

www.phaidon.com

First published 2005
© 2005 Phaidon Press Limited

ISBN 0 7148 4402 0

A CIP catalogue record for this book is available from the British Library.

Designed by Pentagram
Translation by Imogen Forster
Printed in Italy

Contents

Facing One's Own
by Henri Peretz

The family has a dual status. It is both a legal structure and the framework for interpersonal relationships, and in recent times more emphasis has been placed on its emotional than its institutional aspects. The connections between the family and photography have been evident since the invention of the medium; photography quickly became a family activity, and the family photograph was one of its recurrent subjects.

The family photograph falls into four different genres. From the start, professional photographers, frequently working in a studio, provided those celebrating significant moments in their lives with images of themselves. These portraits of newly-weds and new babies make up the family albums that have been kept and handed down from generation to generation. They follow set rules governing background decor and the way the figures are arranged, rules that define a genre that was imposed on obedient subjects. During the nineteenth century, while photographic procedures remained complicated, the studio photographer had a near-monopoly in this field. Then came a number of technical advances.

In 1854, photographs made using small-format glass plates began to appear on visiting cards. These *cartes-des-visites* were exchanged and disseminated, and had to be presented in some way; a book with small frames to hold the cards was the forerunner to the photo album. Then, in 1883, George Eastman invented roll film, which together with the Kodak camera in 1888, put family photography within the reach of a wider public.

The amateur thus became one of the steadfast practitioners of family photography. While the studio photographer was involved only on special occasions, the amateur recorded the little events that make up the fabric of everyday family life. Traditionally it was the man of the family who took on the role of keeper of its collective memory, while it was primarily women who put together the albums as part of their home-making activities. Both studio and family photographs are a form of social celebration: they record the stages at which new members are integrated into the family – through marriage or birth – and reinforce the sense of belonging to the group.

Whether artist or photojournalist, the professional photographer, free from any obligation to celebrate the family, witnesses other aspects. His vision may be humorous, capturing a comical detail; it may be emotional, or a cool record of poverty, but it will inevitably view its subjects with a certain detachment. During the 1930s the underprivileged family became a central theme in documentary photography. In the United States it featured prominently in the programme of the Farm Security Administration, and left to posterity two powerful images of the Great Depression: in 1936, Walker Evans photographed white sharecropper families in Hale County, Alabama, and Dorothea Lange's work on the exodus of rural families from the South included the emblematic image of the *Migrant Mother*. The lives of poor black families in Chicago are recorded in Russell Lee's work of 1941, a tradition of documentary photography that continues in Bruce Davidson's 1967 images of families living on Manhattan's East 100th Street. These records of hardship may be contrasted with the French photographer Robert Doisneau's playful pictures from the 1940s and 50s of ordinary people and their weddings.

Family photography found its broadest expression when it was applied to humanity as a whole, in Edward Steichen's project, 'The Family of Man'. In 1955, Steichen assembled 503 photographs from 68 countries in an exhibition at the Museum of Modern Art in New York. Arranged by theme, from birth to death, they trace significant moments in family life. All are in black and white and the majority were taken out of doors – only one in ten is an interior shot. Some are by leading photographers of the day, others by unknowns. They are infused with an epic spirit, and the exhibition's success reflects the resurgent faith in the human race in the wake of World War II. This universalist project, far removed from a personal encounter between the photographer and his closest relatives, was, however, naive in its apparent belief that all families, in every country, are the same.

The register that informs this book is that of photographers who find their subjects in their immediate family circles. Photography of one's kith and kin has become an established genre, whether it attempts to tell a story, to describe a personal bond, or is an aesthetic project that forms part of a larger body of work. By photographing his family, the artist turns his back on remote, public subjects in order to investigate kinship. He makes the most common of projects – the consecration of the family – his own. In doing so, he risks discarding an aesthetic appropriate to the professional photographer and his work may be assimilated to some degree with the practice of the amateur. He observes the people with whom he lives on a daily

basis, and, in some cases, before significantly turning to the outside world, devotes himself to studying those with whom he is so closely involved. From the outset, such photographers tend to situate themselves within the schema of the traditional family unit, in which the constant figures are the spouse or partner, parents and children. It is hardly surprising therefore that children are the central figures in many of these portraits, as if photography were appropriating from classical painting the traditional image of the holy family. Children are the focus of care and concern within the family and they are the living embodiment of the passing of time during a period when personal identity is being developed. Thus understood, this photography usually expresses positive feelings: love for the members of one's family and its expression through the scenes that are selected.

Those who photograph their own families may work in various genres. This could be an aesthetic approach that forms part of the photographer's work as a whole. What is the photographer attempting to show through the images of his close family that he could not show using other models? The extreme case is when a close relative represents the ideal figure; then we come face to face with the unique relationship between the artist and his model, the nude model in particular. In this case the issue of a connection through blood or marriage is transcended by the attempt to discover the eternal feminine. The familial aspect, devoid of social context, is played out in the subject's full integration into the photographer's formal project; the image is stripped of all tangible signs that the two are related. Nevertheless, the subject, an intimate, offers herself freely and uninhibitedly to the photographer, confident of a mutual understanding that an ordinary model does not enjoy.

At the opposite extreme, the most frequent approach is to take snapshots of family members. A photographer is almost never without his camera. He is always ready to capture a gesture or an expression that intrigues or moves him. This is the practice on which visual narratives of family life, whether improvised or carefully planned, are based. Each moment of daily life is there to be recorded in all its profound ordinariness. We are not surprised, therefore, to find people portrayed in the everyday settings of their domestic lives. These settings, or the objects that inhabit them, sometimes become motifs illustrating some aspect of family intimacy.

The photographer constructs an image of the passage of time. Every shot is an opportunity to mark the different stages in a family's evolution. The most radical project is the one in which the photographer himself creates the family moment, and in which posing in front of the camera becomes habitual for the family members. In this way, a family album is produced in which past and present overlap. But, unlike any ordinary family album, this is not exclusively addressed to the family it portrays, but also to the anonymous spectators who give it its status as a work of art.

The photographer is attached to the members of his family, but almost never to its conventionally ritualized moments. He seizes seemingly indifferent moments, paying little attention to the calendar of family celebrations. In this sense he distances himself from the traditional family photograph. Furthermore, unless he is undertaking a specific aesthetic project – working with the nude, for example – the photographer does not use a studio. He photographs people in their natural settings, in familiar interiors and exteriors. Sometimes even a landscape without human figures serves as a metaphor for the family, carrying the strong suggestion that this is where its most intimate moments have been lived. For instance, the garden, as a nurtured space, often evokes the tenderness of family ties.

The modern family favours personal, affective ties over those dictated by a traditional hierarchy of dependency and it is these relationships that are portrayed by many photographers. While sociologists document the decline of the traditional family unit – through late marriage, divorce, the birth of children outside marriage – the impulse and intention behind family photographs remain essentially unchanged. We see photographs that show the effects of the evils of war and of social problems on families in the outside world, but look in vain for images that illustrate the rifts, the conflicts, the tears and hatreds that mark the intimate family life that is led behind closed doors. But if there is a sense of propriety that sets a limit to the representation of private unhappiness, is that to say that there is no public for such subjects? Nostalgia for the past and an affectionate view of the present seem to be the abiding moods. It is only the process of ageing that tarnishes the almost idyllic image with which we are presented in these pictures.

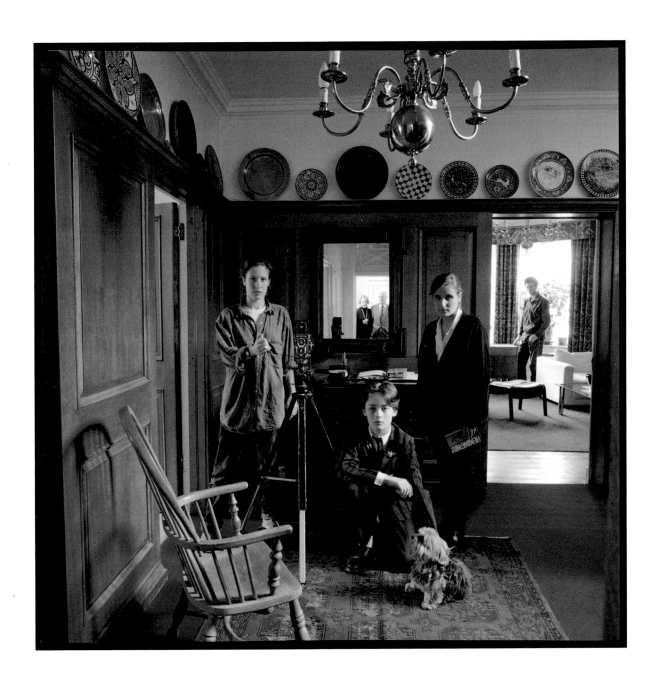

Sivan Lewin *Portrait*, 1993

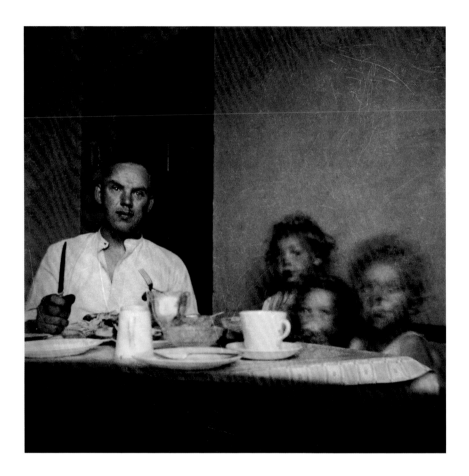

George Albert Newton Smith *Waiting for dinner with our Sheila, Graham and Doreen's little girl, Marleen*, 1949

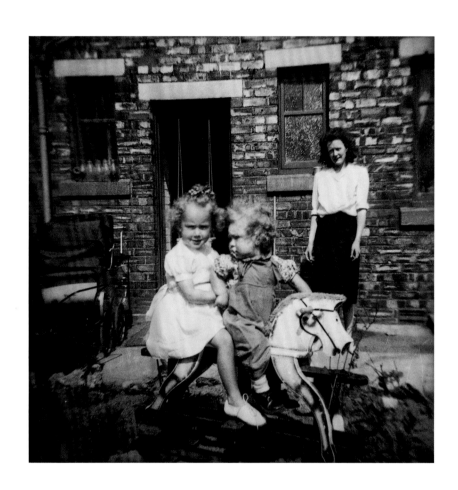

Hilda with our kids, Sheila and Graham, in the back garden at Keith Road. I made the rocking horse, 1949

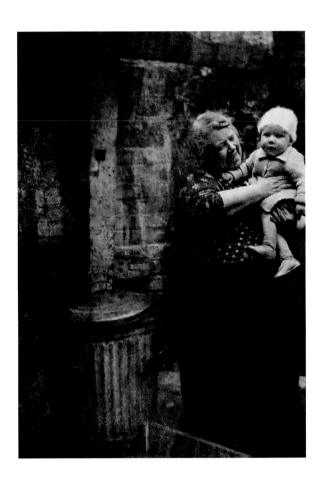

My dear mother Ruth with her first grandson, George. His dad was killed at Dorman Long furnaces
not long after I took this picture, 1938

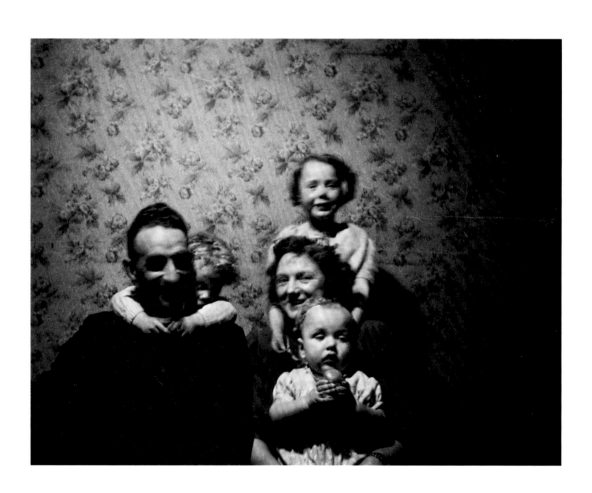

Christmas visit – our Sheila, Graham and Andrew with their auntie and uncle, 1950

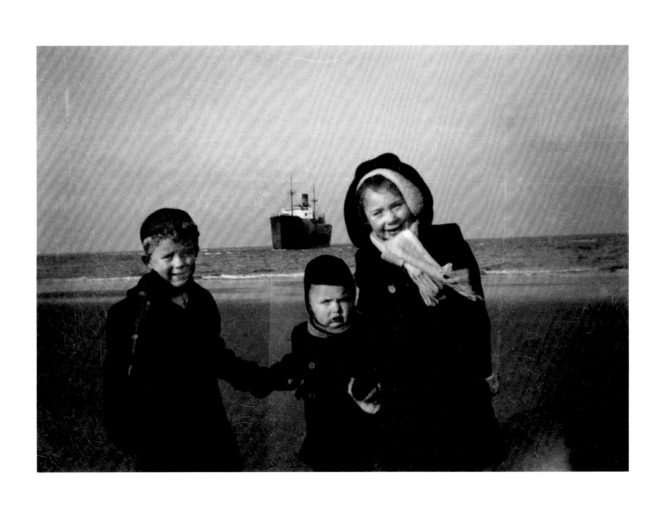

Even though it was a cold day I wanted to show our Sheila, Graham and Andrew the big ship grounded on Redcar sands, 1953

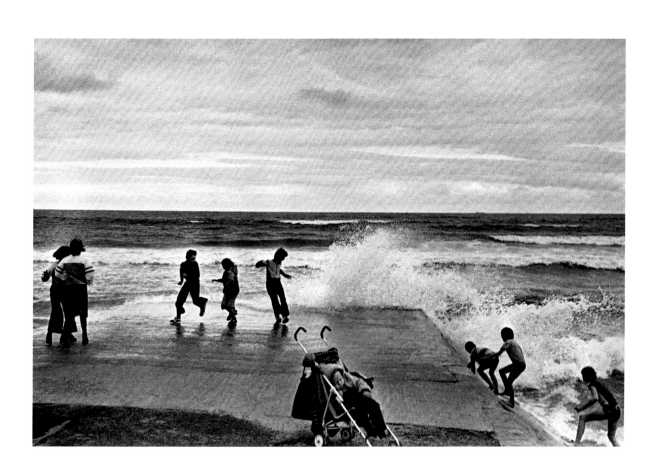

Markéta Luskačová *South Shields, NE,* 1978

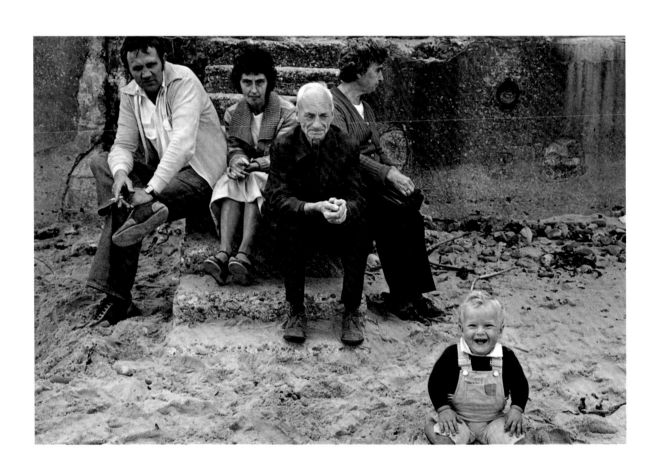

Whitley Bay, NE, 1978

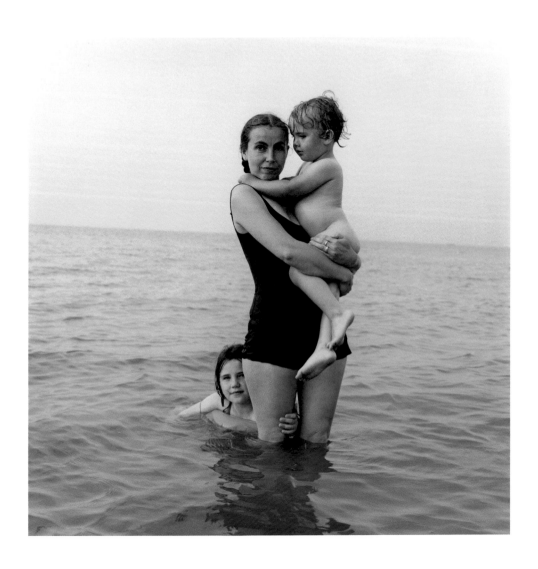

Robin Grierson *Rebecca with Lottie and Milo, Seasalter,* 2001

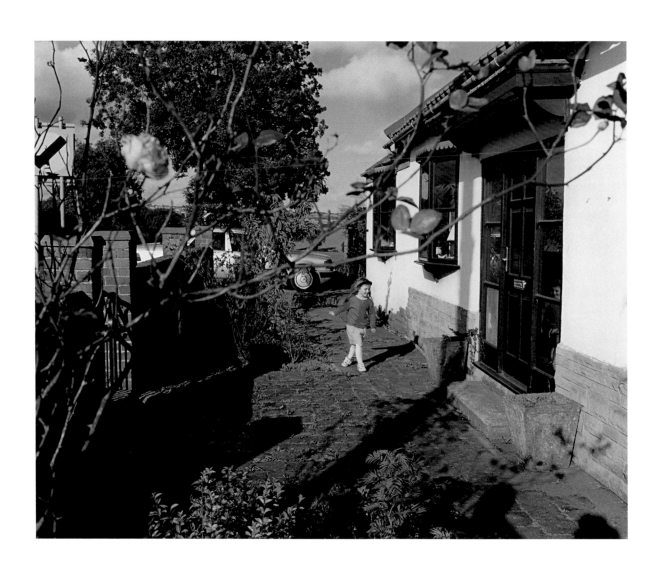

Daisy in my mam's garden, Fishburn, Co Durham, 2001

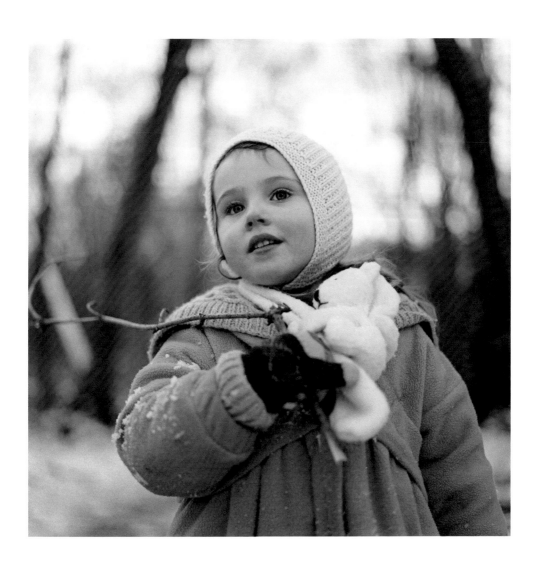

Daisy in the woods, West Wickham, 2001

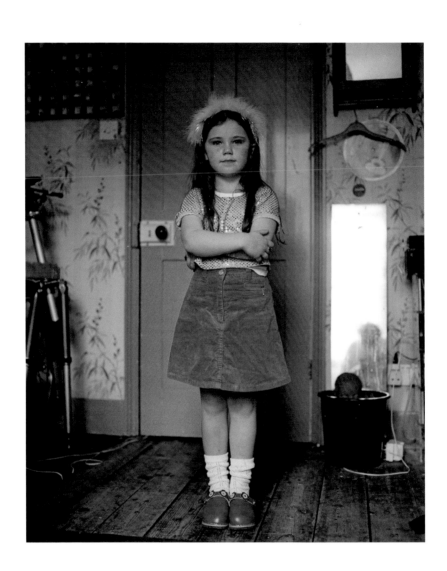

Lottie, Sydenham, 2000

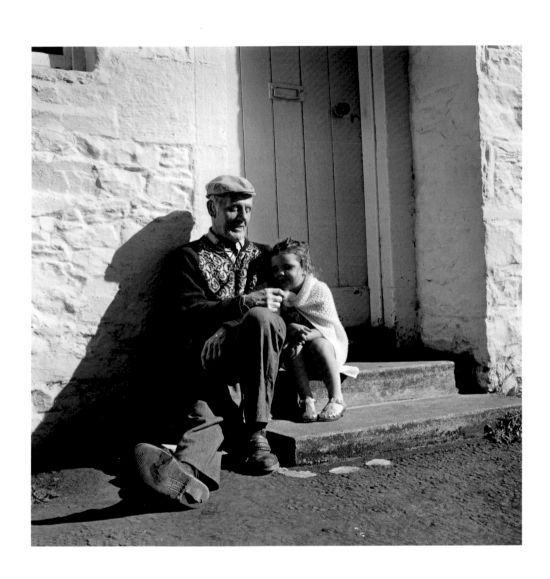

Lottie with Uncle Willie, Wamphrey, 1999

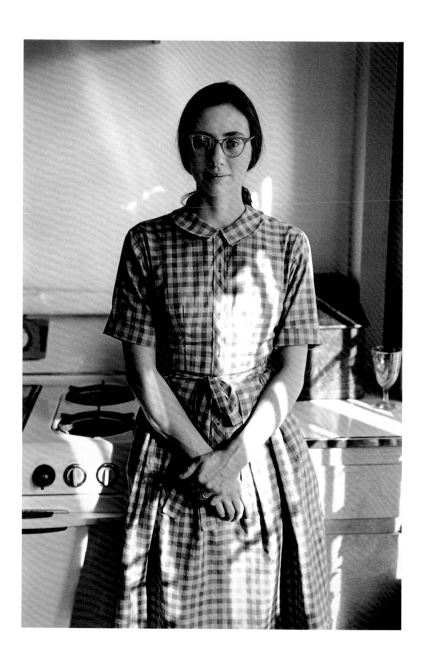

Lee Friedlander *Maria, New City, New York*, 1961

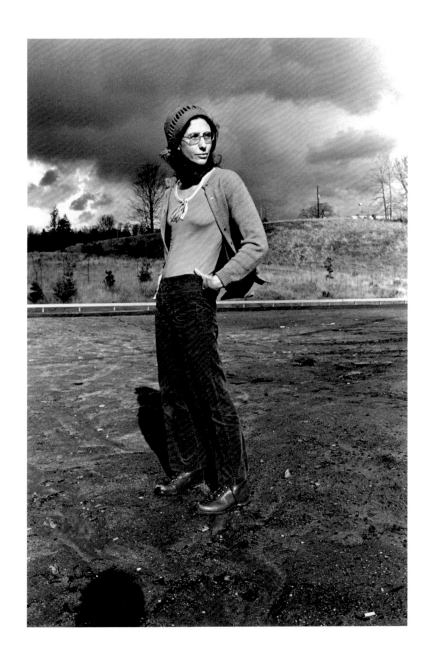

Maria, Katonah, New York, 1972

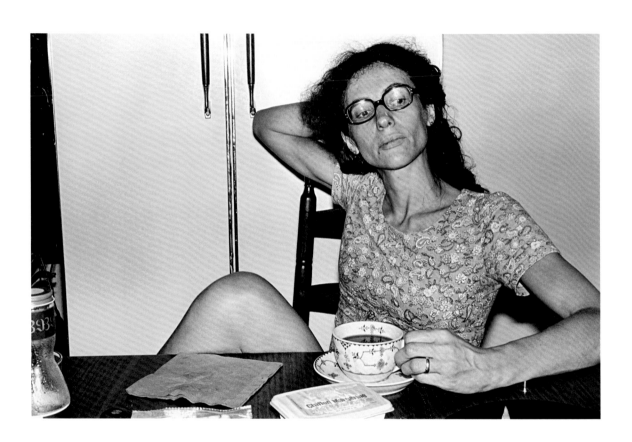

Maria, New City, New York, 1970

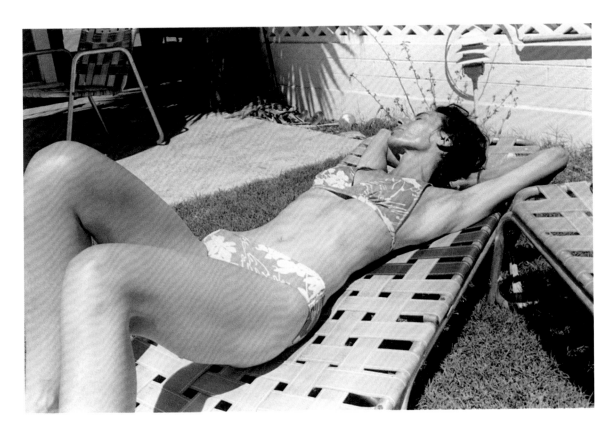

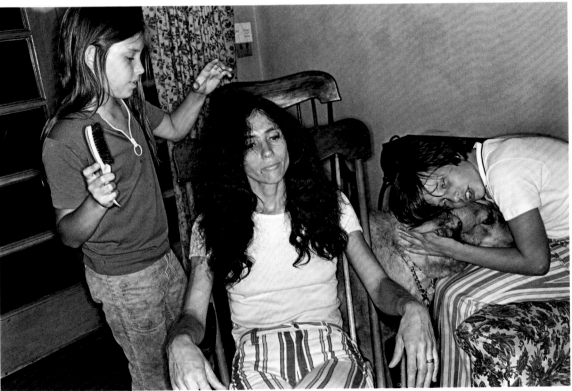

Maria, Tucson, Arizona, 1977. Maria, New City, New York, 1972

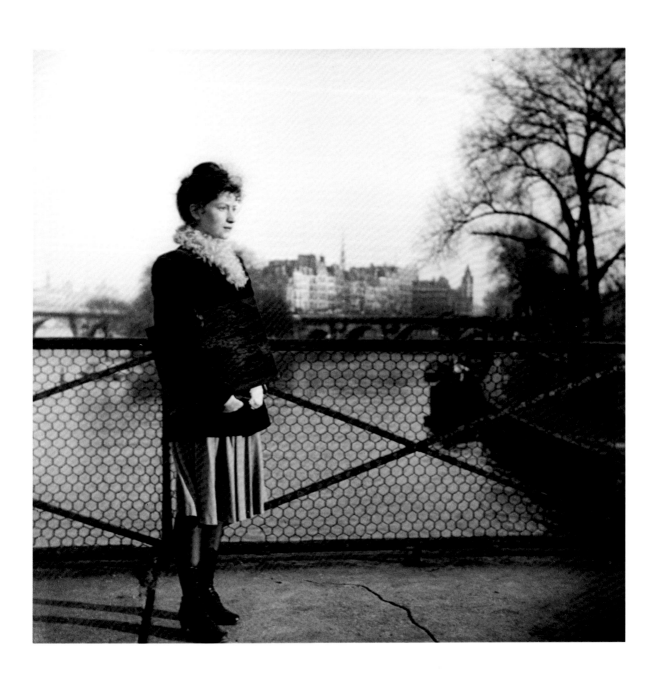

Edouard Boubat *Lella, Pont des Arts, Paris,* 1948

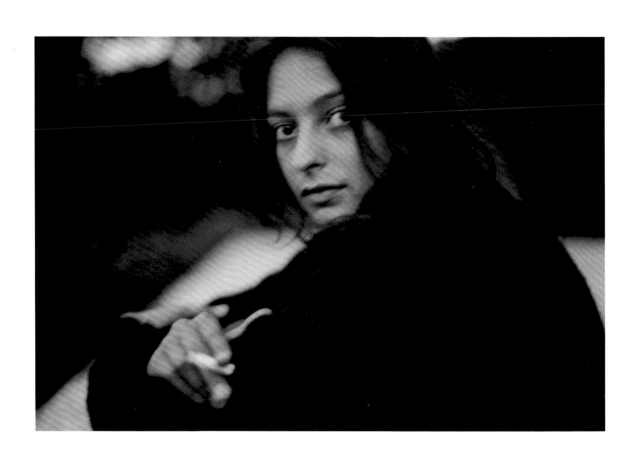

Bernard Plossu *Françoise*, 1980s

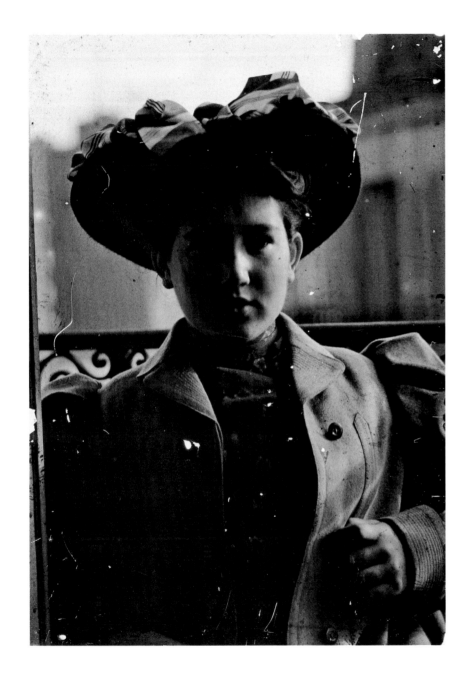

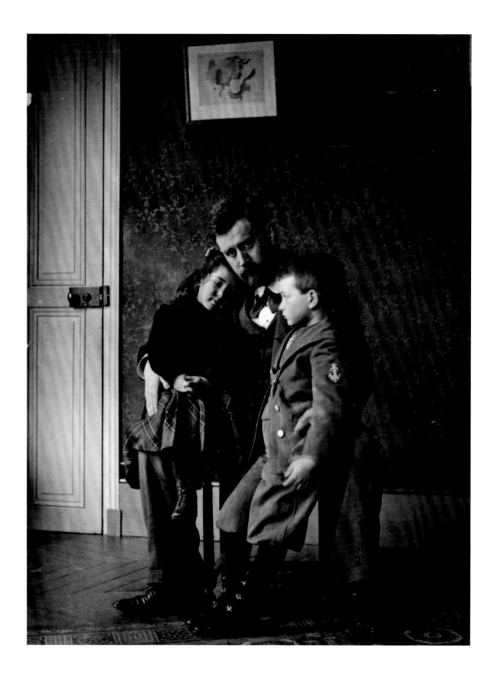

Jules Antoine *Marthe*, C. 1907 *The photographer with his children Marthe and Jean*, C. 1898

Le Sommeil, 1980s

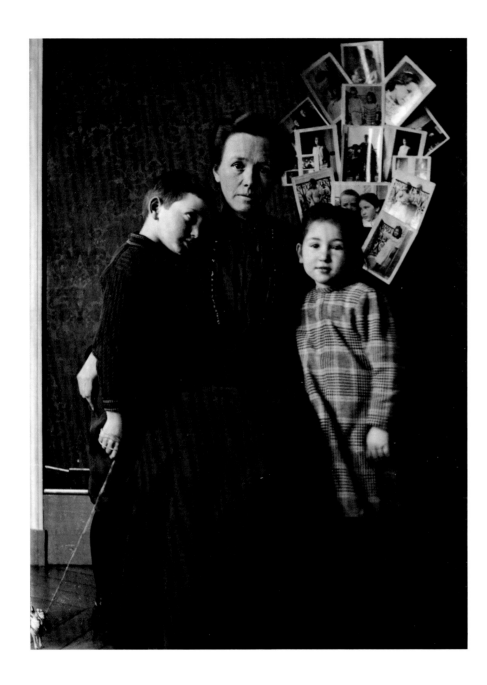

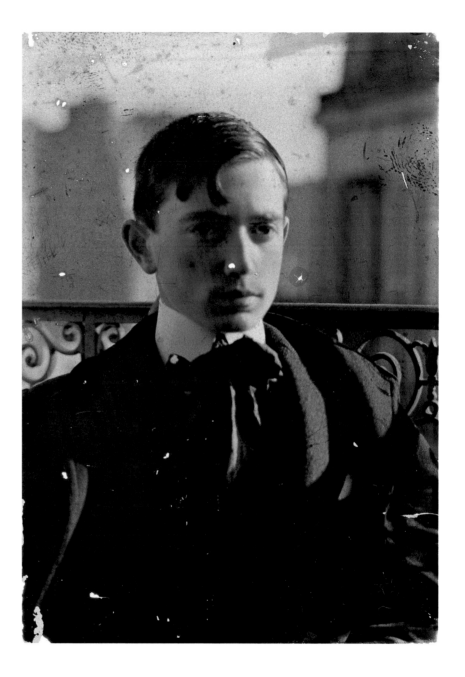

Pauline, the photographer's wife, with their children Jean and Marthe, C. 1898 *Jean*, C. 1907

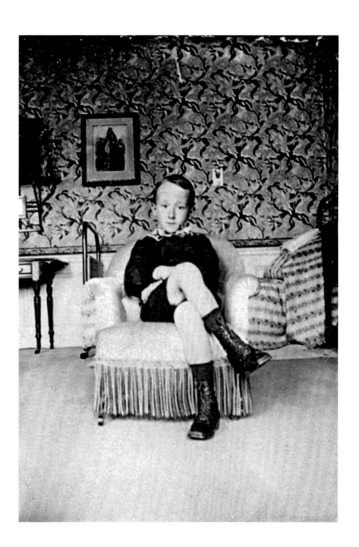

39 **Jacques-Henri Lartigue** *My cousin André Haguet, nicknamed Dédé, Paris,* 1906

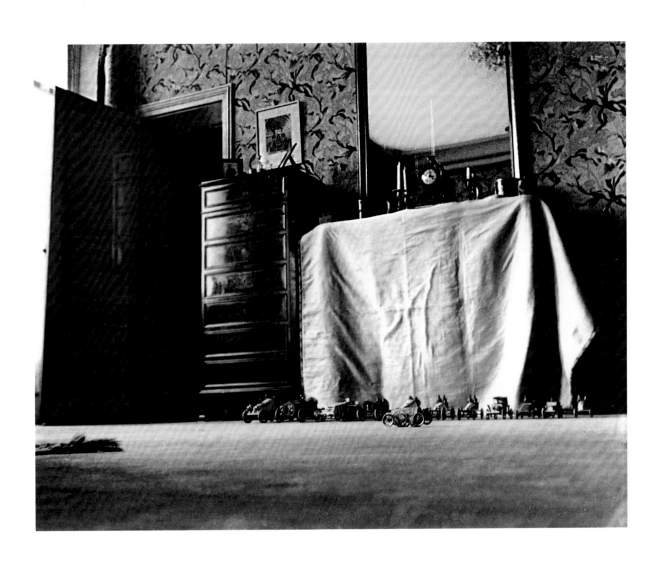

In my bedroom, my racing car collection, Paris, 1905

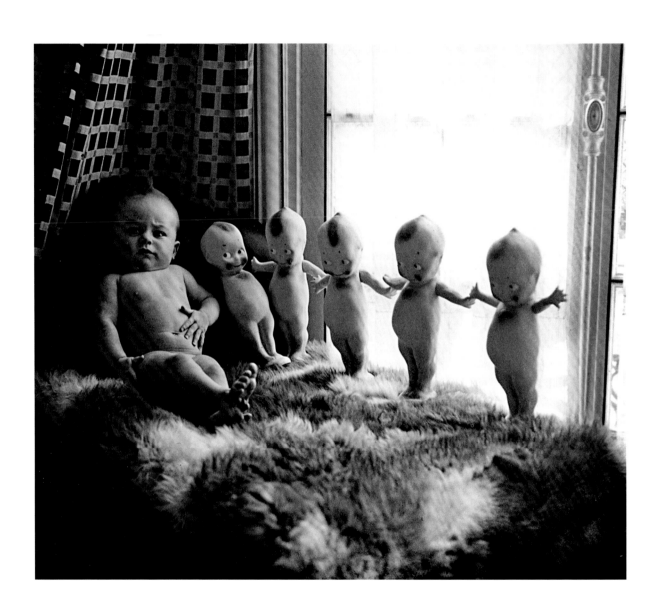

Dani at 6 months, Paris, February 1922

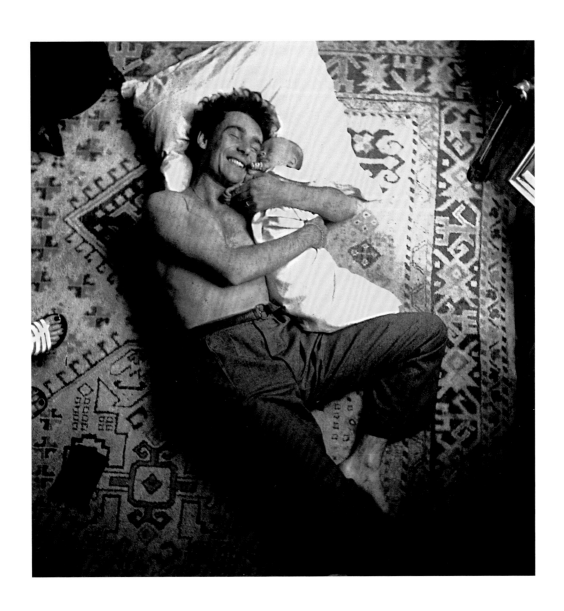

Dani with his son, Paris, 1944

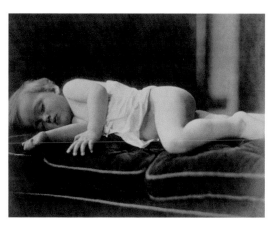
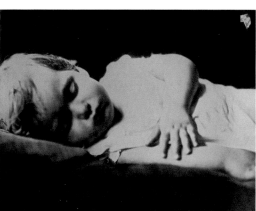
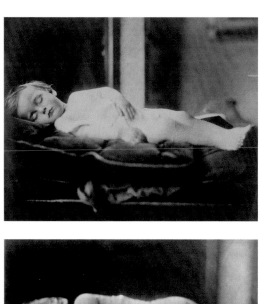
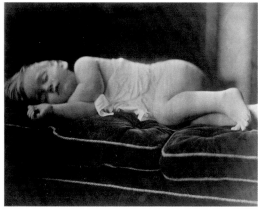

Julia Margaret Cameron *My grandchild Archie, Eugene's boy, aged 2 years and 3 months, born at Barbados*, 1865

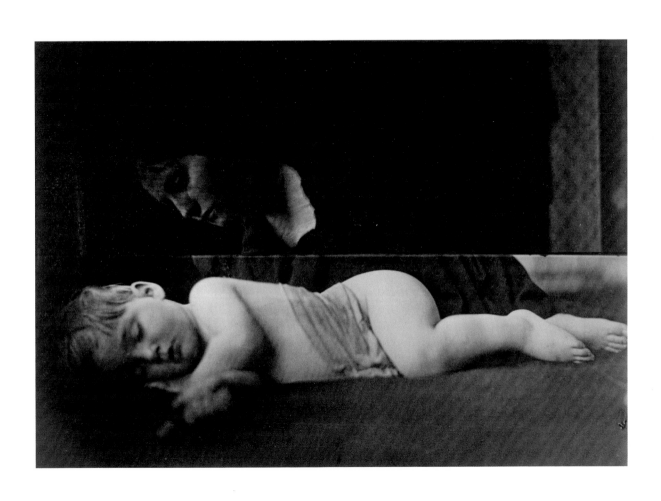

Mary Hillier and Archibald Cameron, 'Madonna and Child', 1865

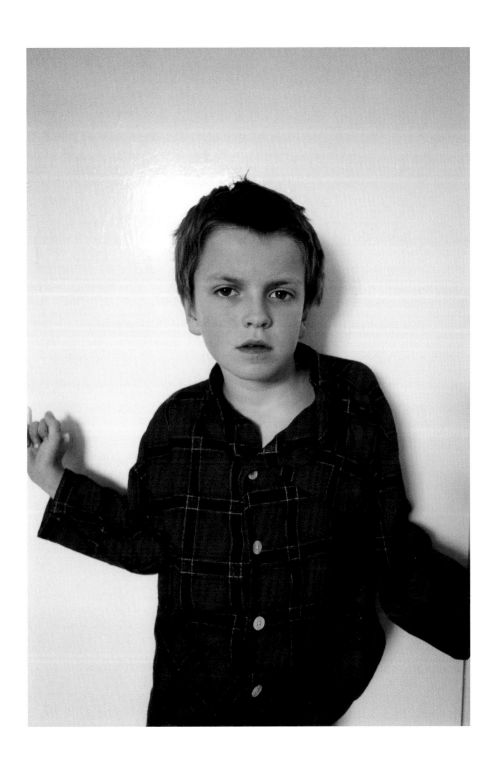

Joëlle Dépont *Max in his red pyjamas, July 2000*

Max in Pelion, Greece, 3 June 2000

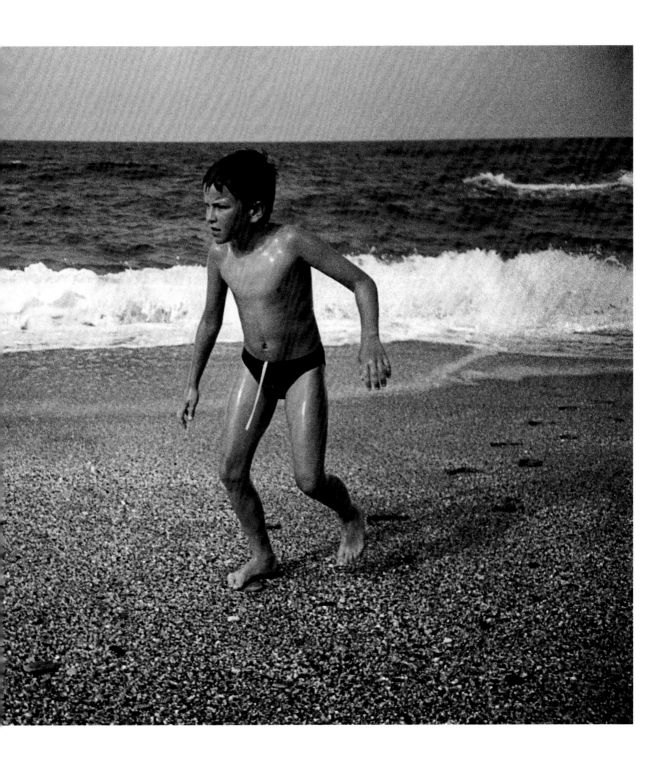

Paul Reas photographs from PORTRAIT OF AN INVISIBLE MAN, 1993–2003

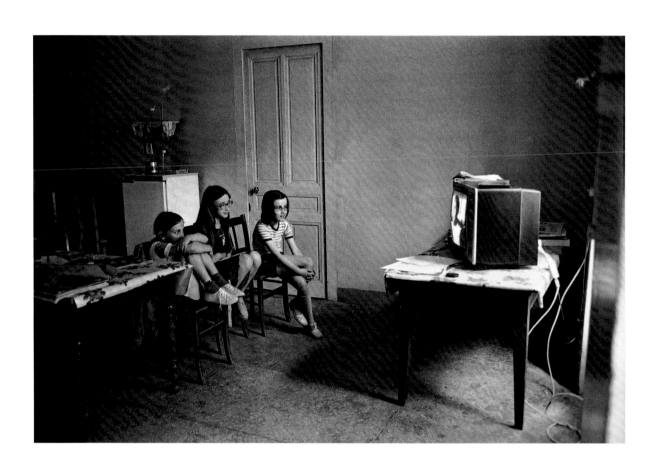

Raymond Depardon *During the day my little nieces made use of the television,* 1979

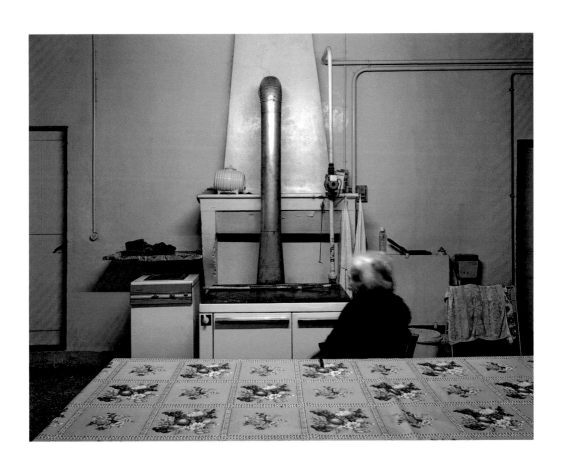

During the four-minute exposure my mother moved slightly, 1984 53

The farmyard. One of my first photographic prints, 1957

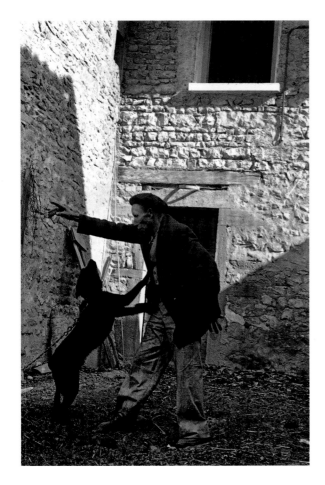

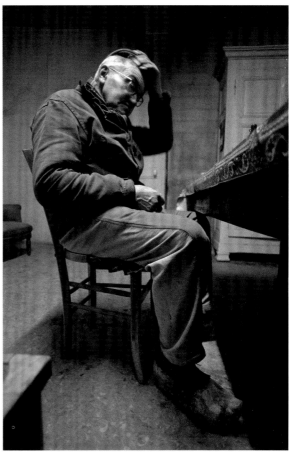

My father had confidence in Sylvestre. He and I loved Pernod the dog, 1957
Always elegant in his way my father dressed in blue, winter and summer, 1982

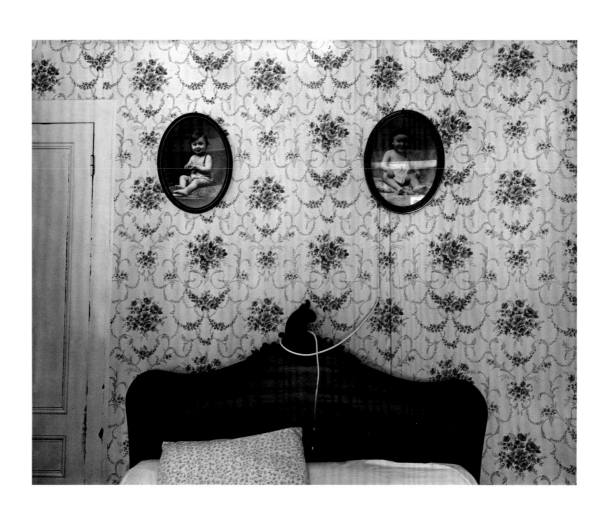

In my parent's bedroom nothing has changed, 1984

Le Garet farm, 1984

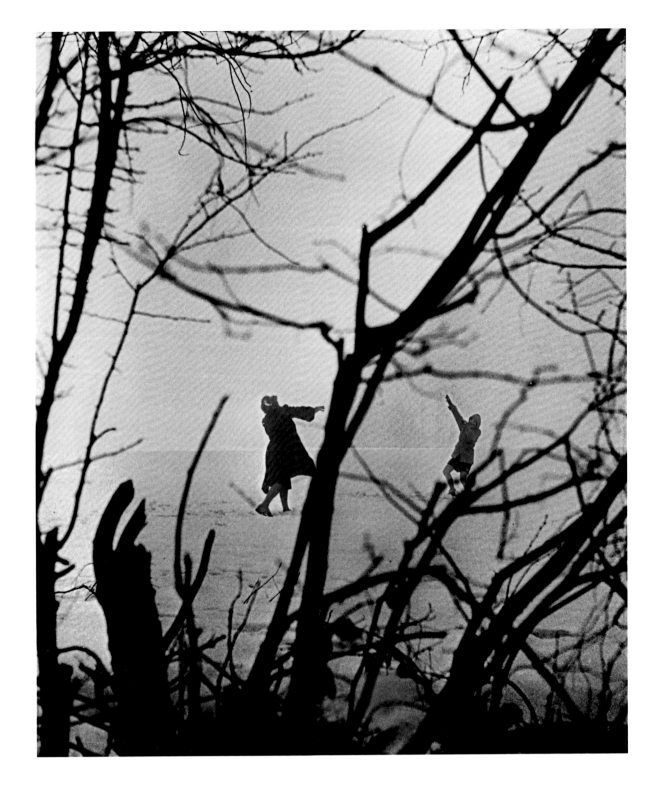

Willy Ronis *Marie-Anne and Vincent in the snow, Ile-de-France*, 1952

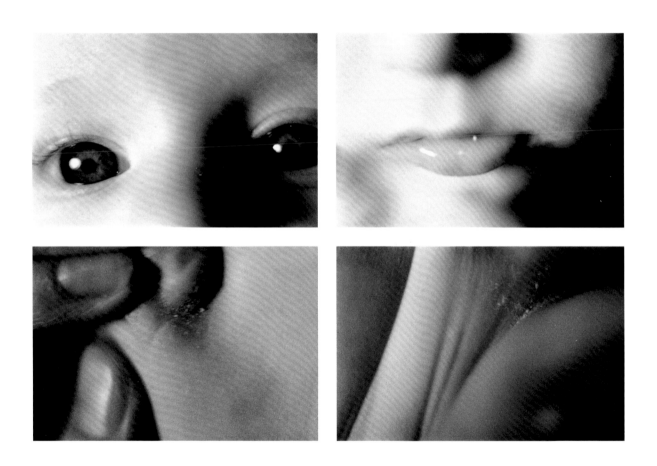

Mary Kelly photographs from PRIMAPARA, 1974

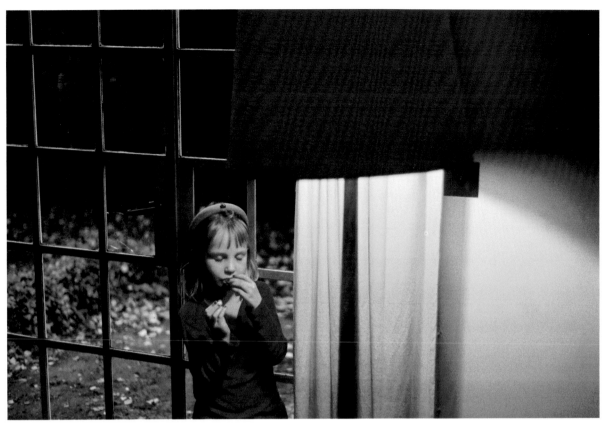

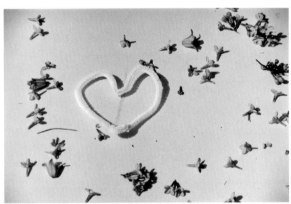

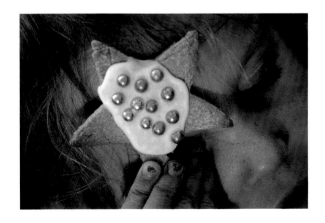

Susan Andrews *Lois*, 1996–2002

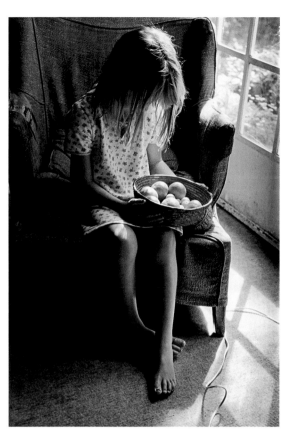

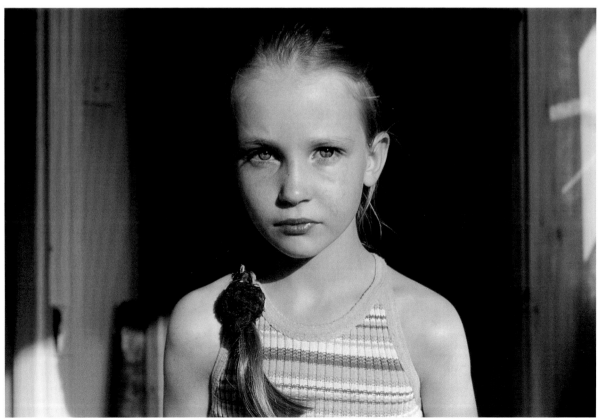

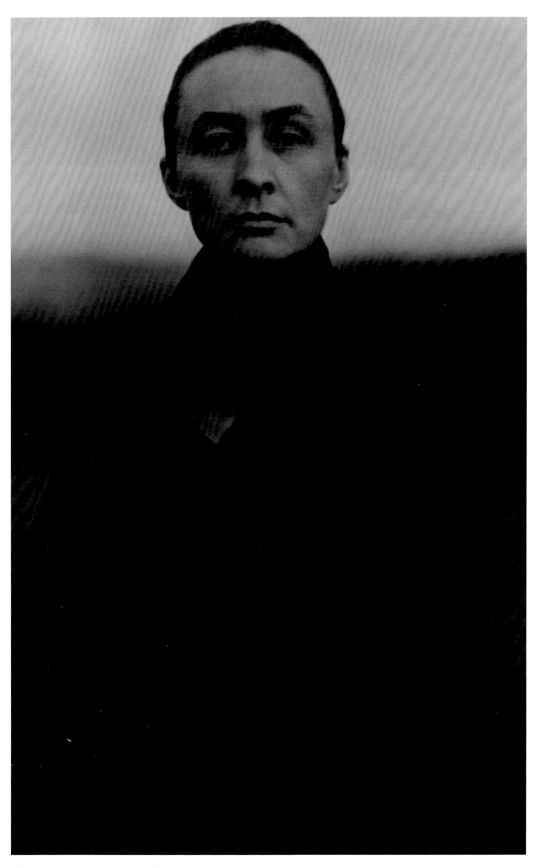

Alfred Stieglitz *Georgia O'Keeffe,* 1920

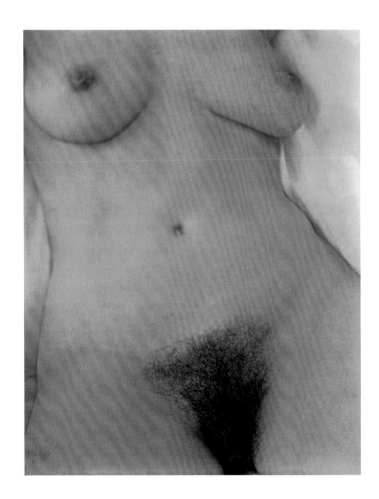

Georgia O'Keeffe – Torso, 1921

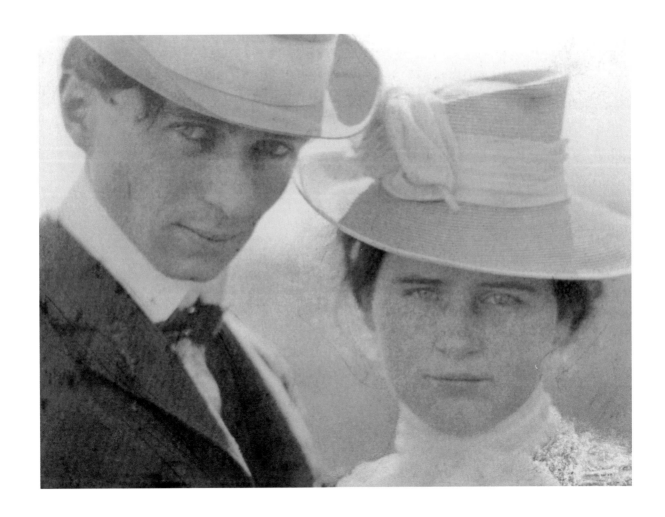

Edward Steichen *Self-portrait with my sister*, 1900

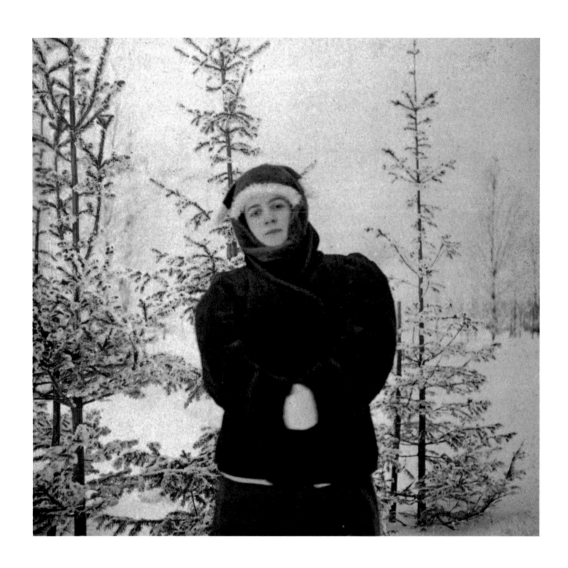

Leonid Andreyev *Anna, the photographer's wife, in the garden of the Vammelsuu house, early* 1910s

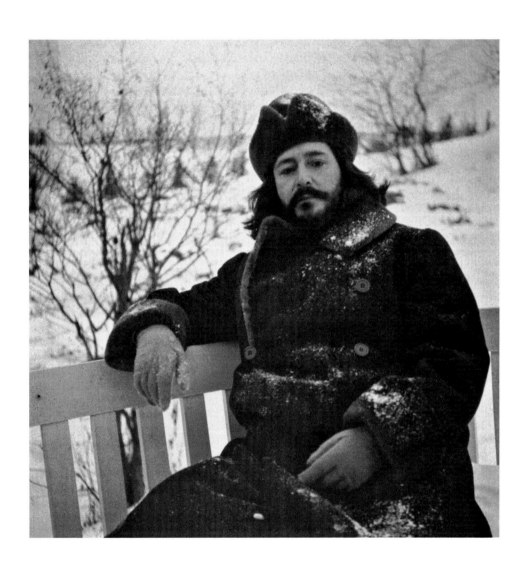

The photographer in the garden of the Vammelsuu house, early 1910s

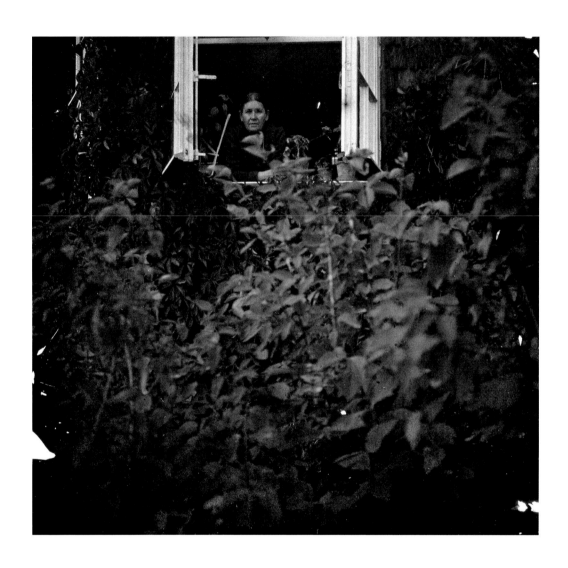

Anastasiya, the photographer's mother, looking out of a window at Vammelsuu, early 1910s

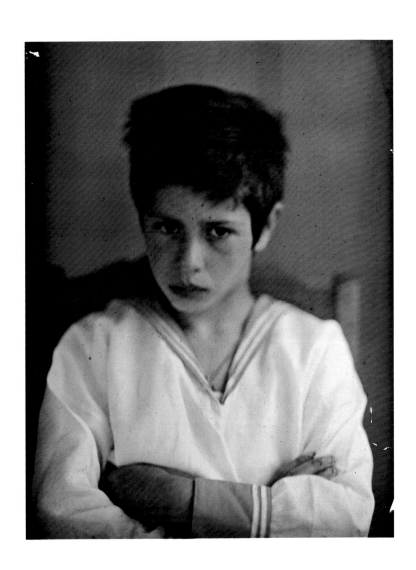

Vadim, the photographer's eldest son by his first wife Aleksandra, early 1910s

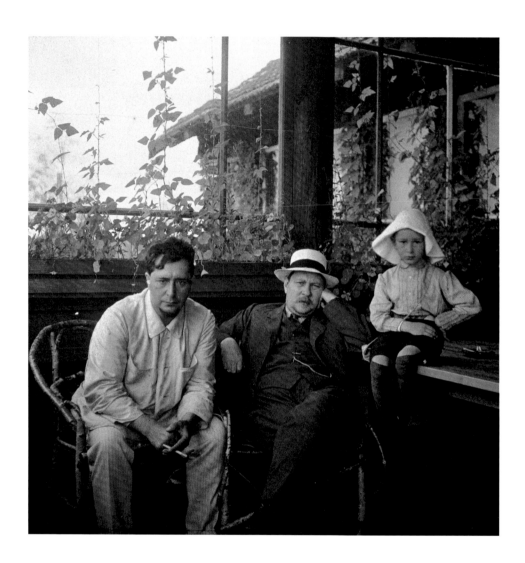

The photographer with Filip Dobrov, his brother-in-law, and Daniil, his youngest son by Aleksandra, early 1910s

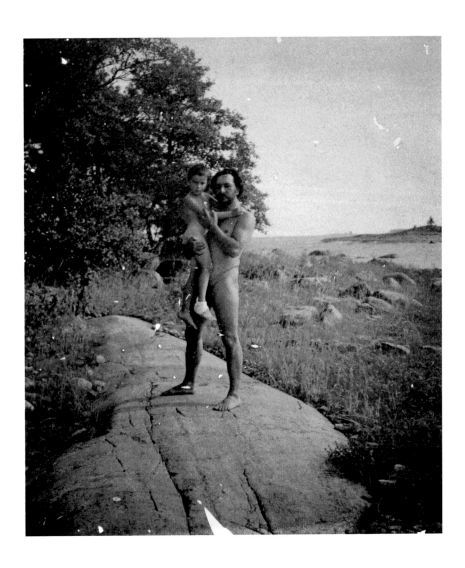

The photographer with Savva, his eldest son by Anna, nude on one of the islands in the skerries, early 1910s

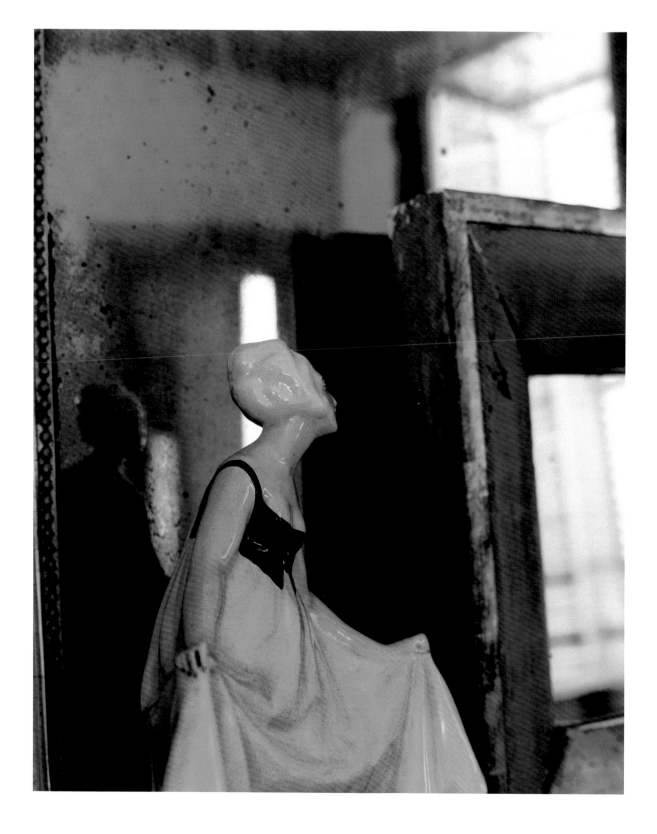

Sophie Ristelhueber *#10*, 1995

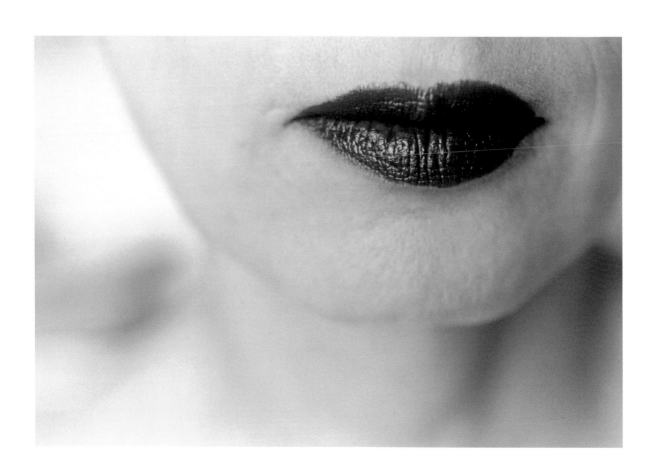

Elinor Carucci *My mother's lips*, 1997

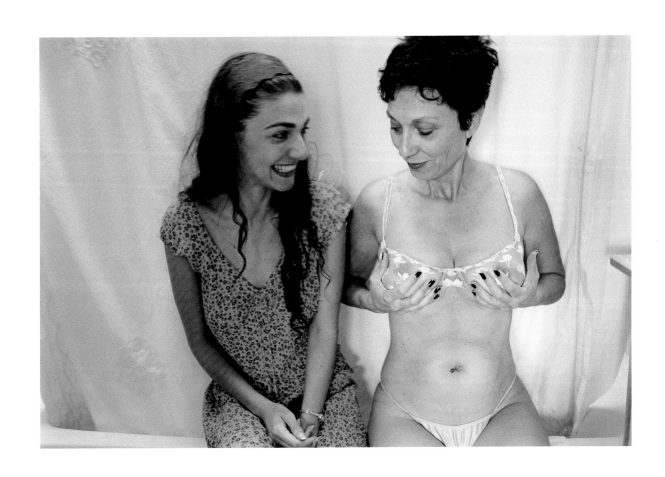

Mother and I, 2002

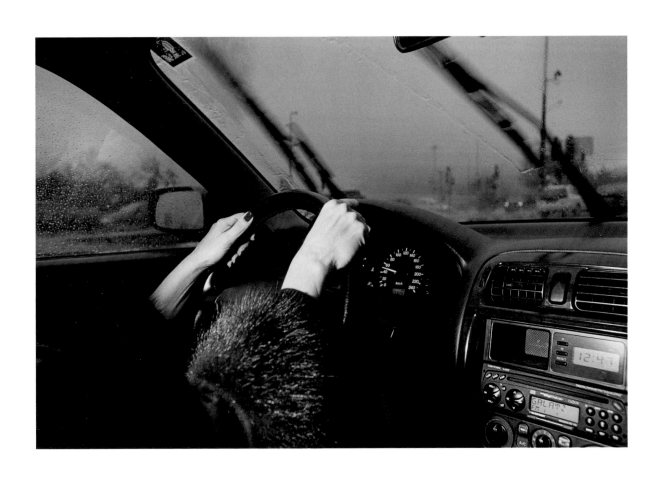

Mother drives me in the rain, 2000

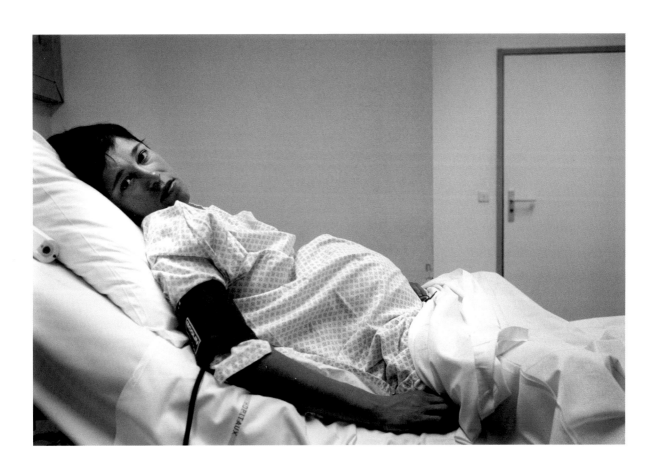

Gautier Deblonde *Waiting for Victor, 27 October 2003*

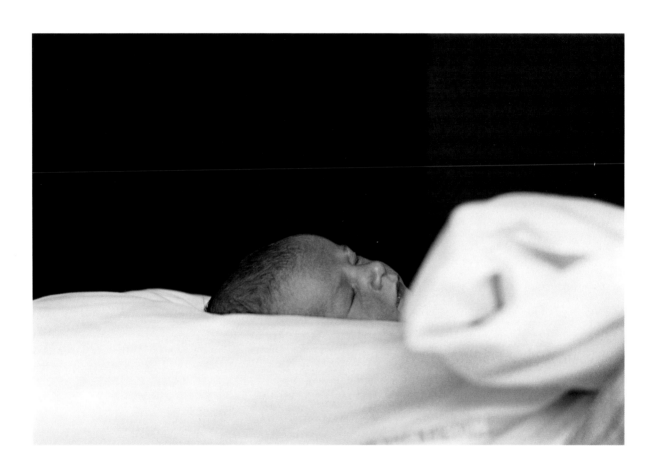

Victor, white sheet, 28 October 2003

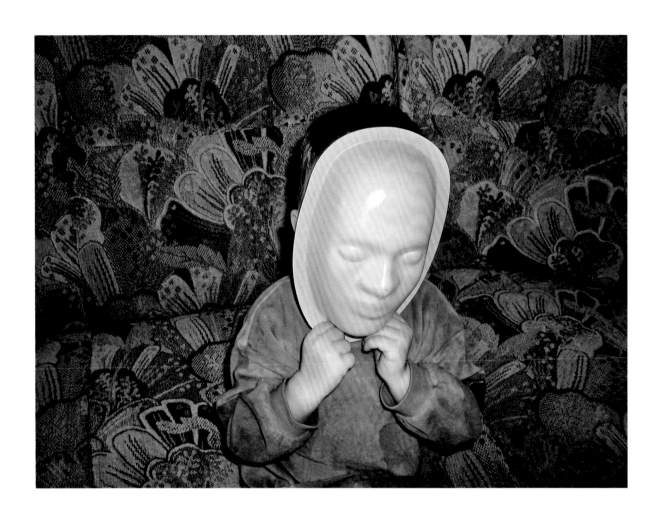

Vlado Bohdan *Prague*, 2003

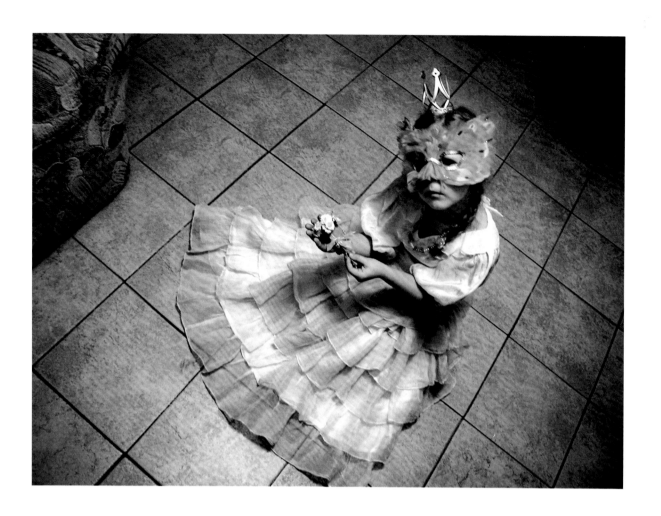

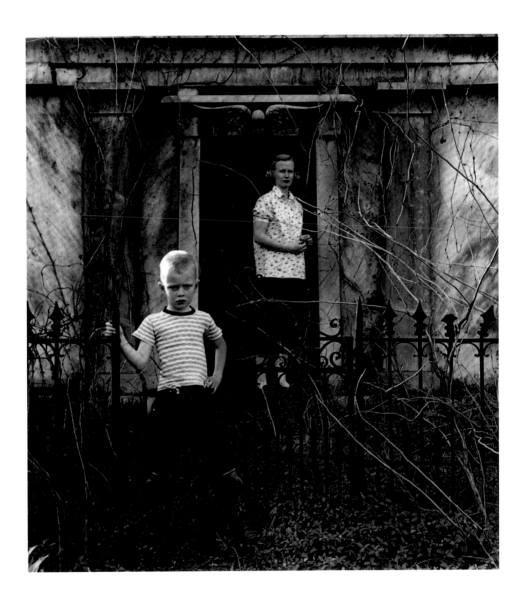

Ralph Eugene Meatyard *Untitled (Michael and Madelyn), Lexington Cemetery, Kentucky,* 1955

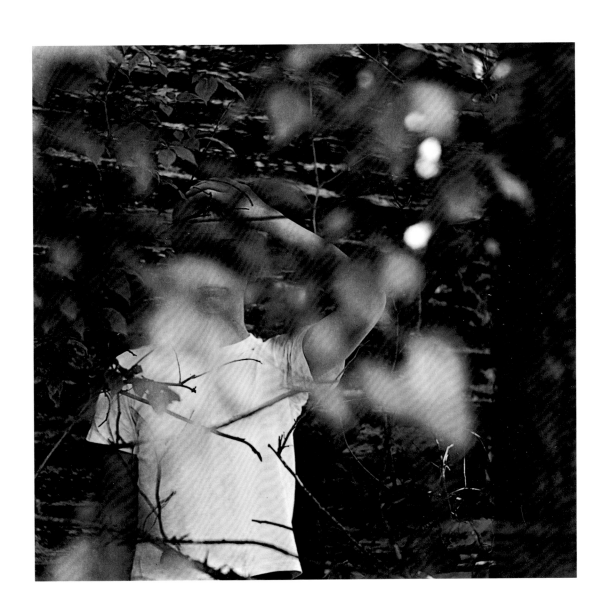

Untitled (Michael behind the leaves), 1963

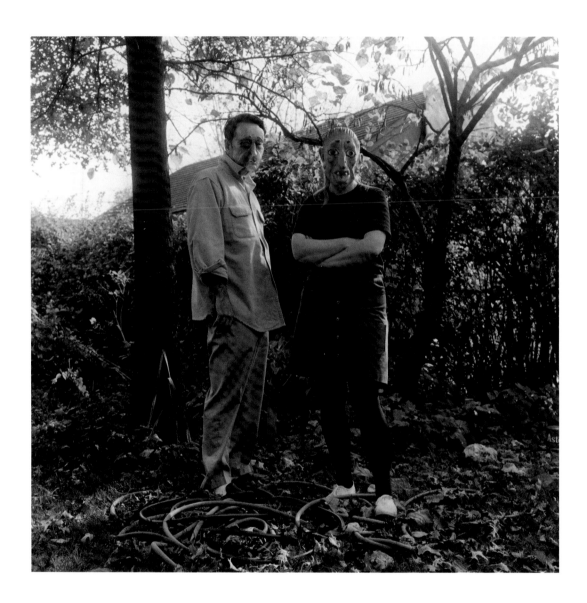

Lucybelle Crater and her 40-year-old husband, Lucybelle Crater, c. 1970–1

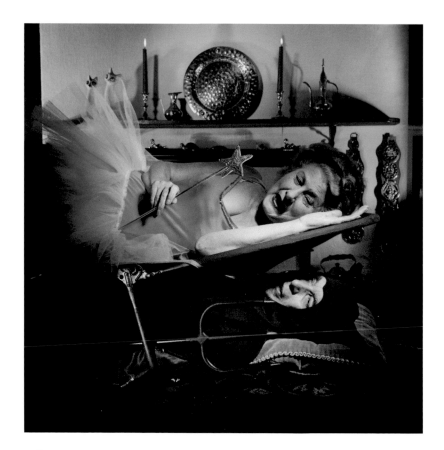

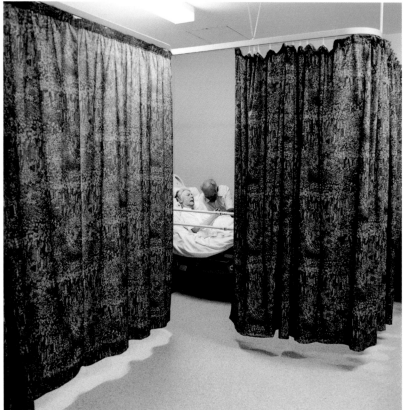

Colin Gray *Heaven and Hull*, 1990. *Life Support*, 2000

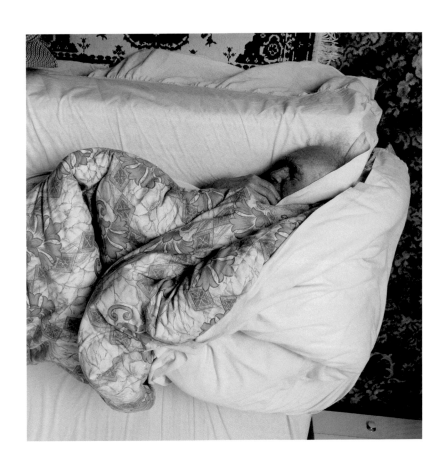

Duvet Day, 2002

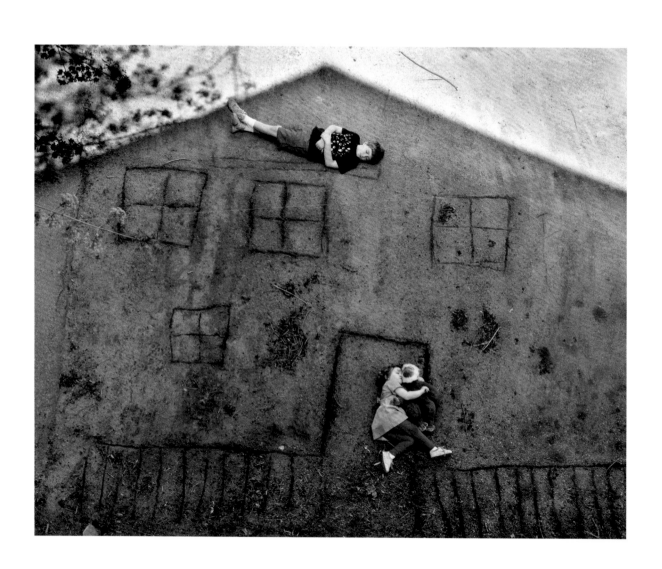

Abelardo Morell *Laura and Brady in the shadow of our house*, 1994

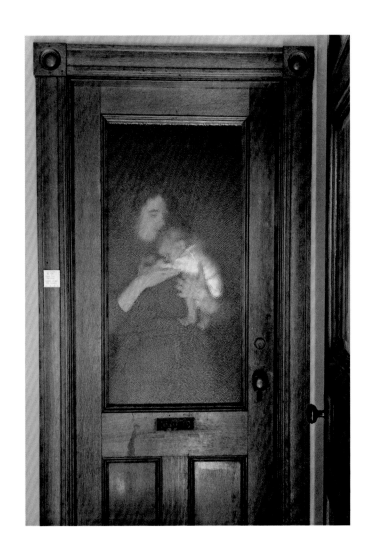

Lisa and Brady, 1986

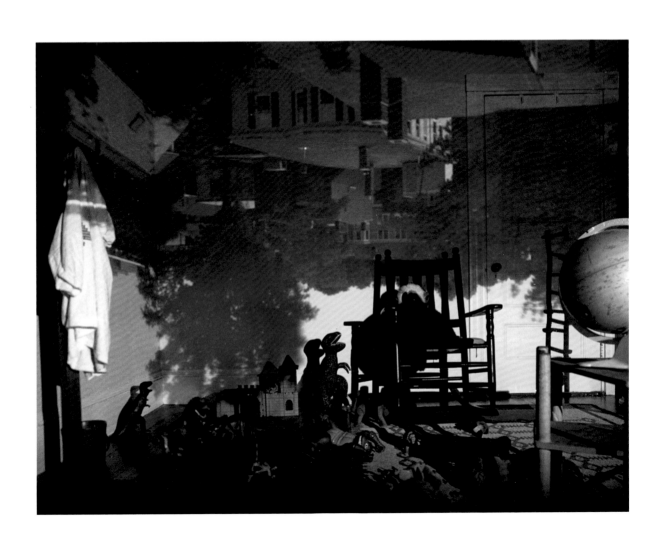

Camera obscura image of Brookline view in Brady's room, 1992

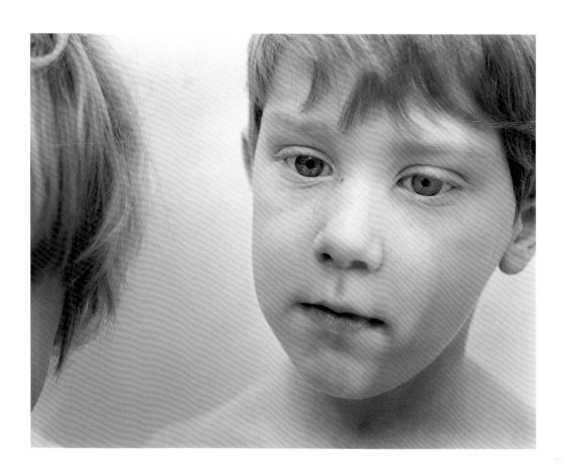

Nicholas Nixon *Sam and Clementine, Cambridge, Massachusetts,* 1989

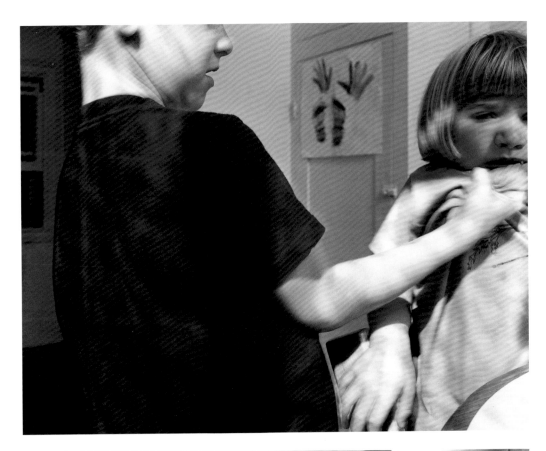

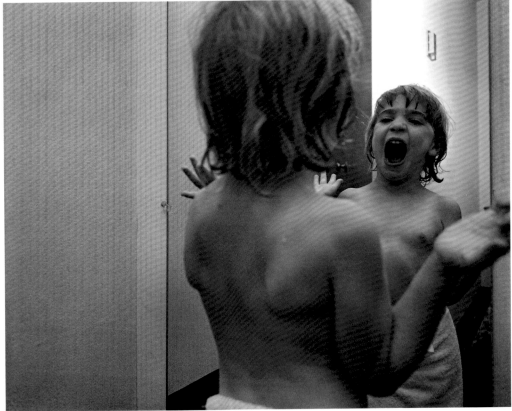

Sam and Clementine, Cambridge, Massachusetts, 1990. Clementine, Clarion, Pennsylvania, 1990

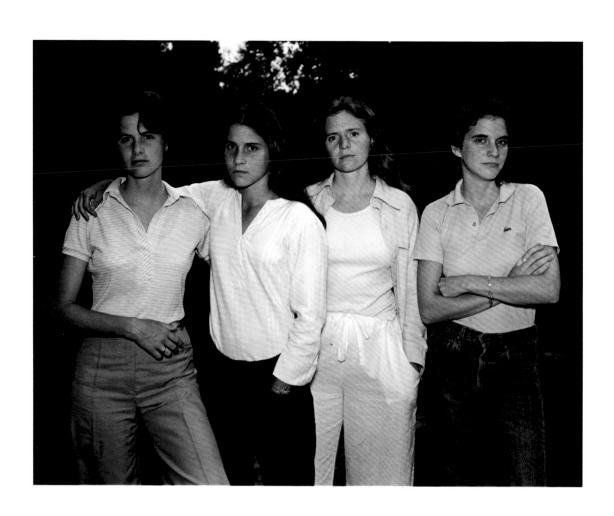

The Brown Sisters, New Canaan, Connecticut, 1975

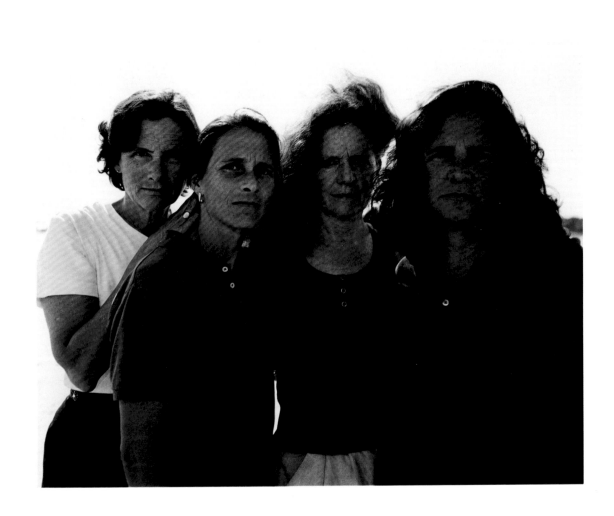

The Brown Sisters, Ipswich, Massachusetts, 2003

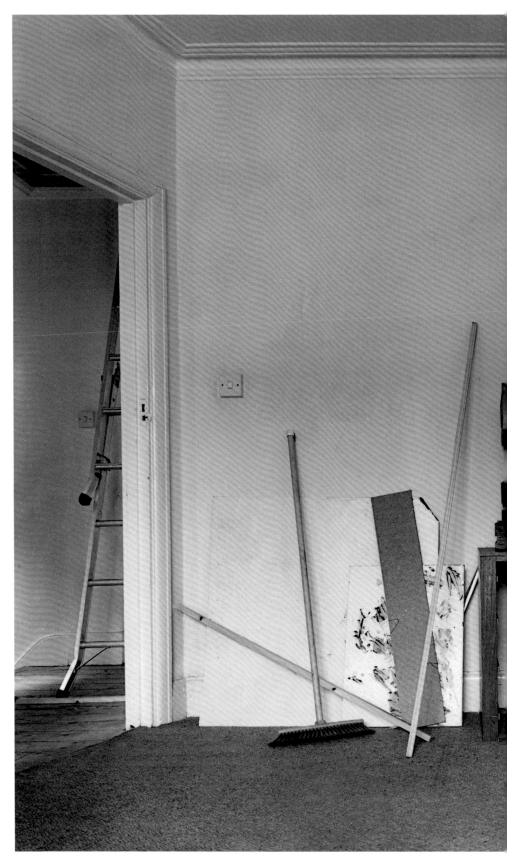

Nigel Shafran photographs from DAD'S OFFICE, 1996–8

Jill and Terry's garage, Dobcross, 1997

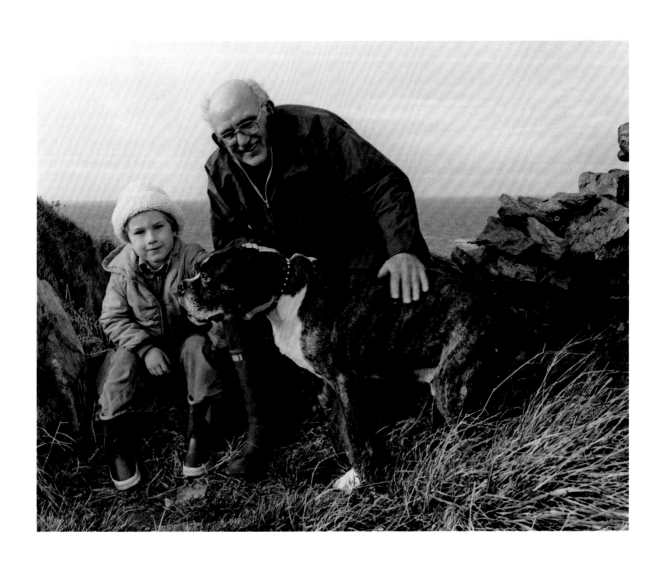

Chris Killip *Matthew Killip (aged 3) with his grandfather Alan Killip and their dog Bruno on the path to the White Beach, Niarbyl, Isle of Man, 1981*

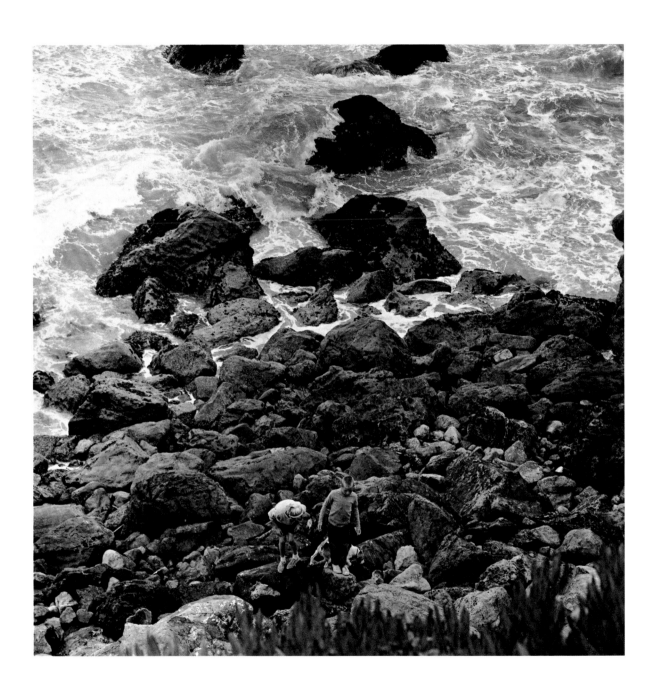

Dorothea Lange *Steep Ravine*, 1961

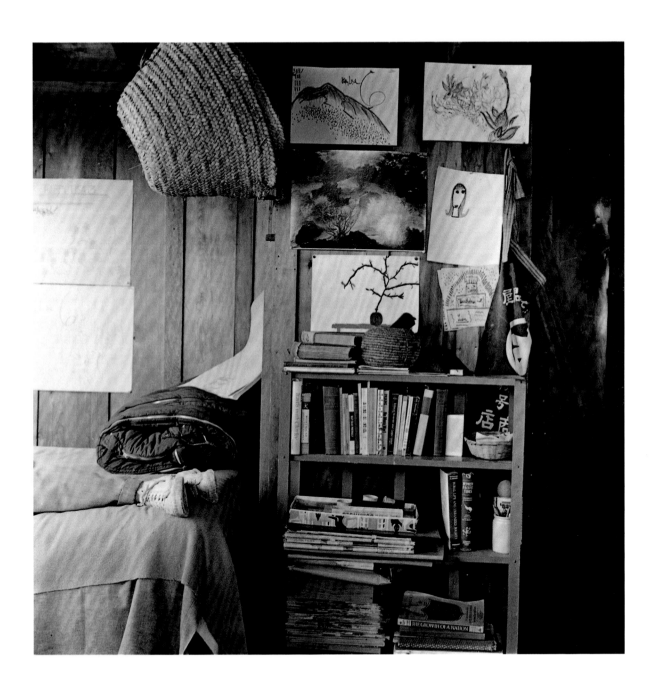

Steep Ravine, 1961

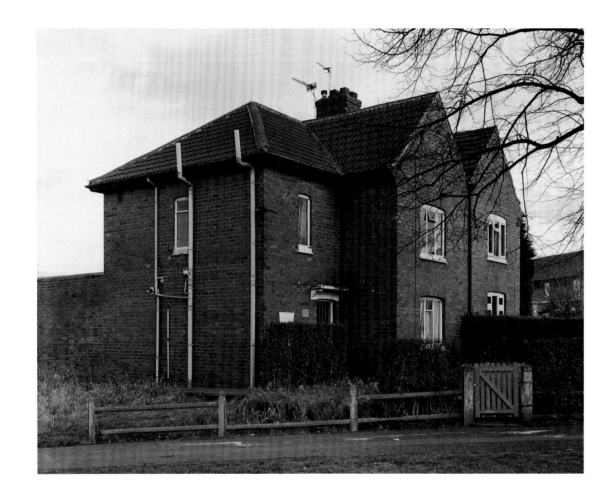

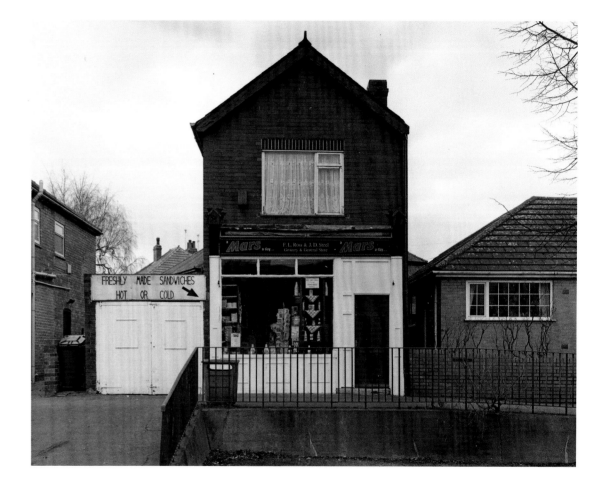

Howard Sooley *The house my father grew up in. His father, Frank Sooley, moved there in 1935 whilst working on the trains for LNER. 161 Sandford Road, Balby, Doncaster, February 2003 (now empty)*

Vernon's greengrocer, Sandford Road, Balby, Doncaster, February 2003 (now a general store)

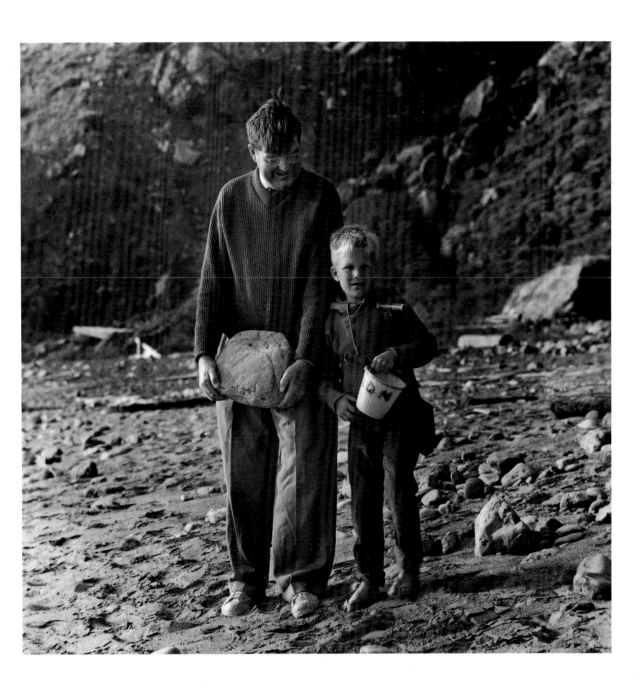

Steep Ravine, 1961

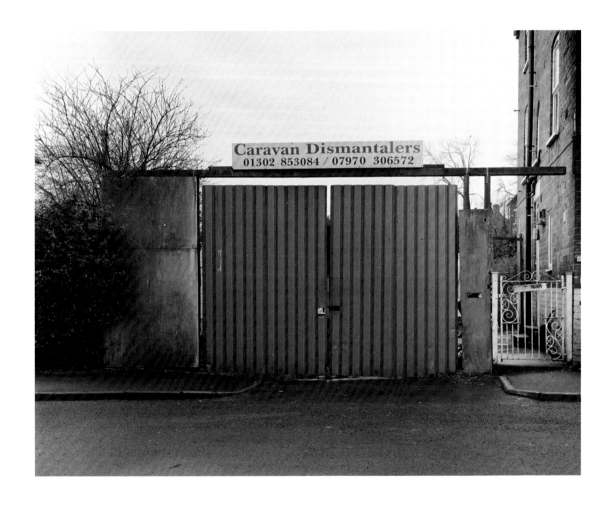

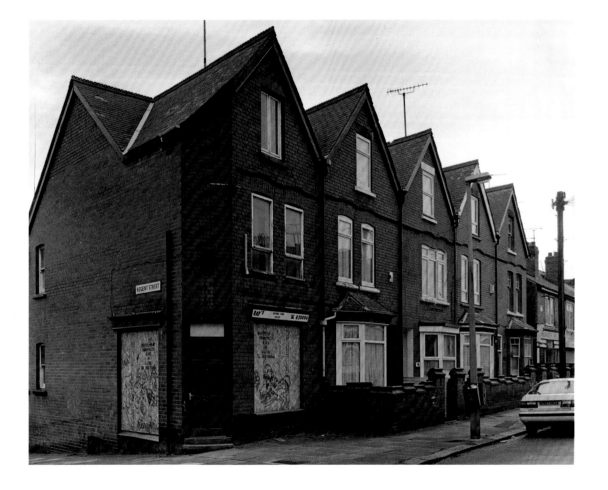

Arthur's shed – bookmaker (illegal) – Woodfield Road, Balby, Doncaster, February 2003 (now a caravan dismantlers)

Mr Myers – butcher – corner of Regent Street and Low Road, Balby, Doncaster, February 2003 (now empty)

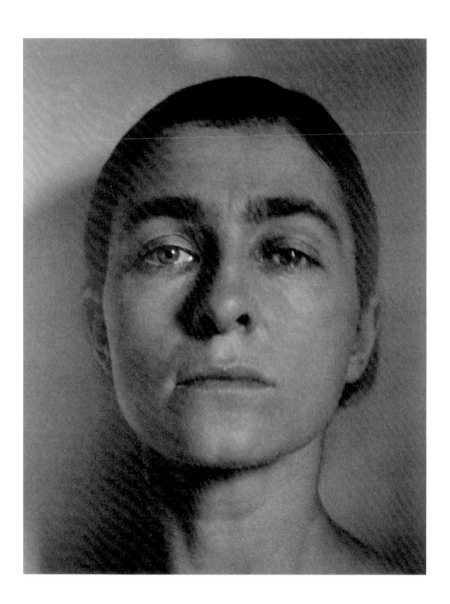

Paul Strand *Rebecca, New York*, c. 1920s

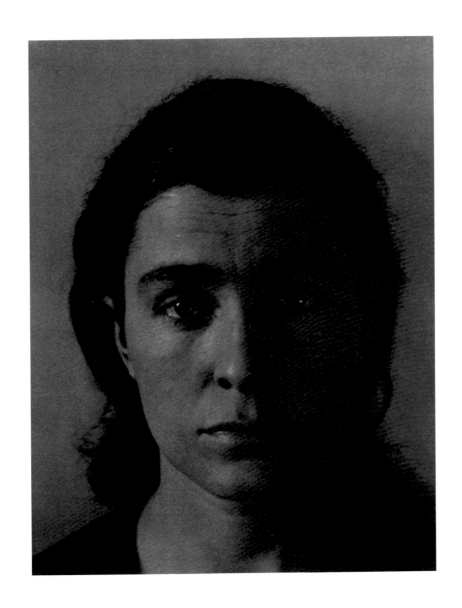

Rebecca, New York, 1922

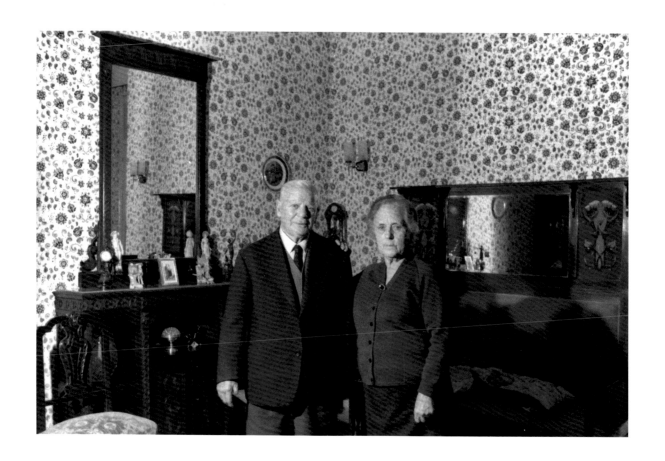

Ferdinando Scianna *My grandparents Benedetto di Fiore and Giovanna Giangrasso on the day of their fiftieth wedding anniversary, Bagheria, Sicily,* 1969

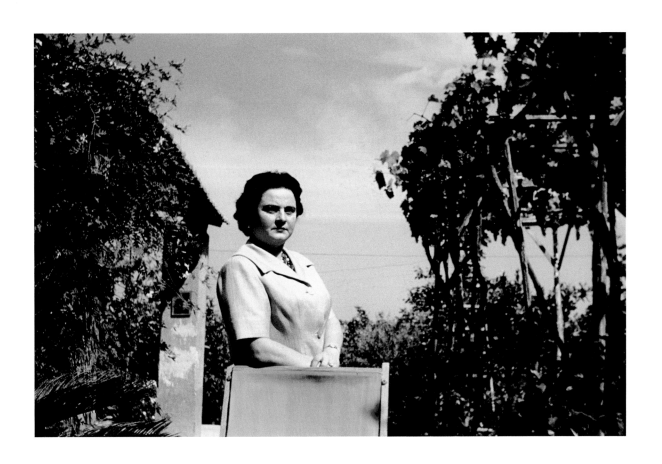

My mother Giuseppina Scianna in Lanza, Bagheria, Sicily, 1960

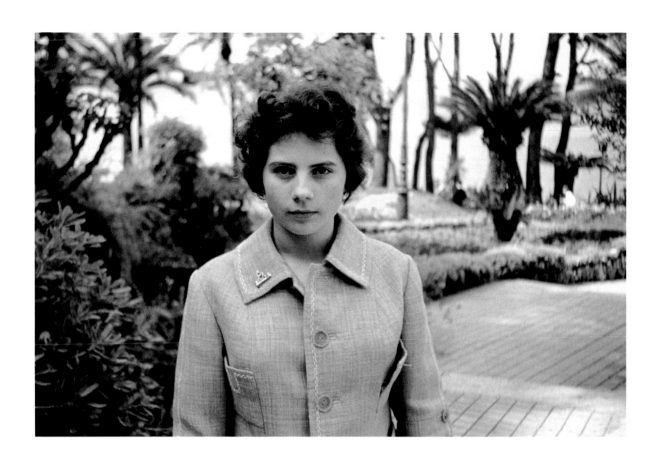

My sister Anna Scianna, Bagheria, Sicily, 1960

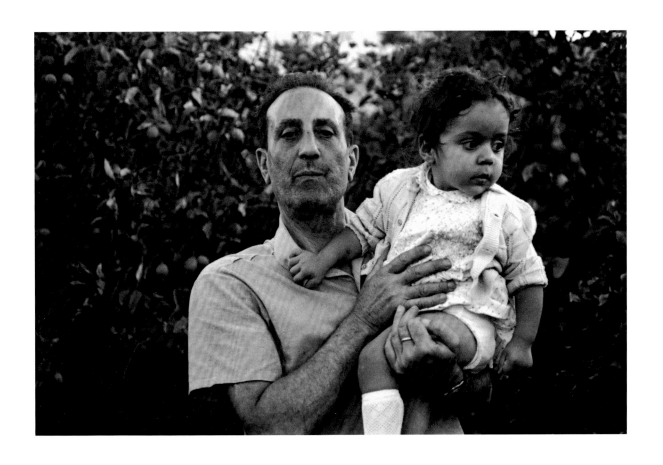

My father Baldassere Scianna with my daughter Francesca, Bagheria, Sicily, 1969

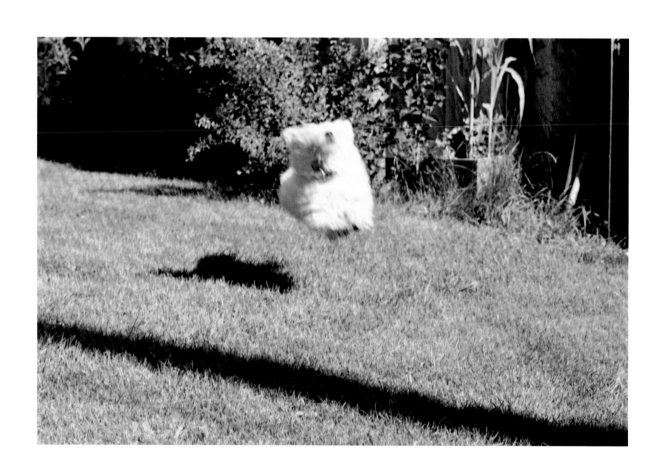

Robert Adams *Untitled*, 1984

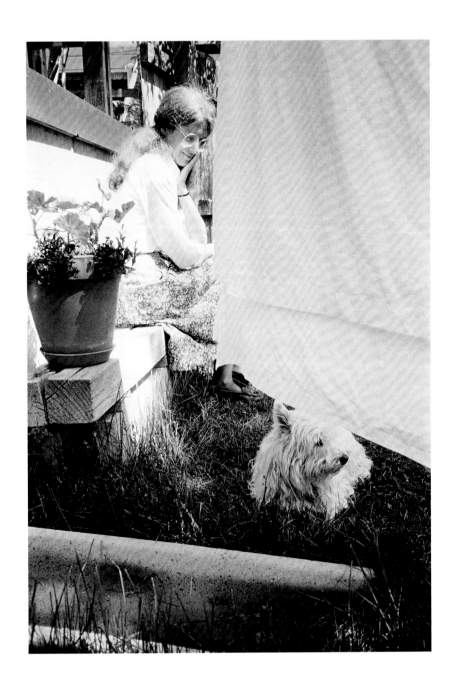

Kerstin and Sally and the wash, 1984

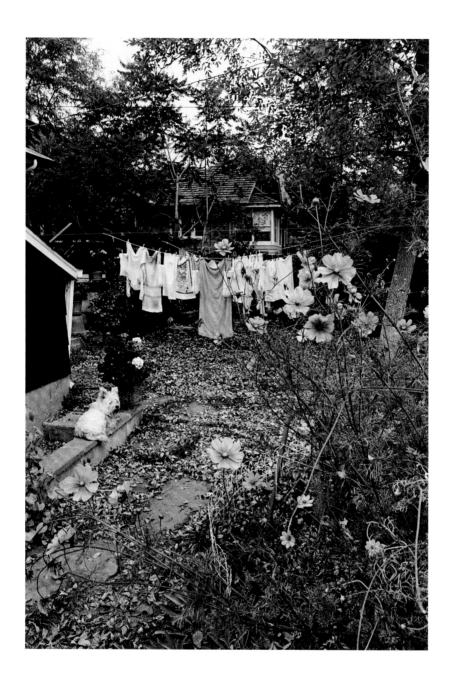

Sally in the backyard, 1990

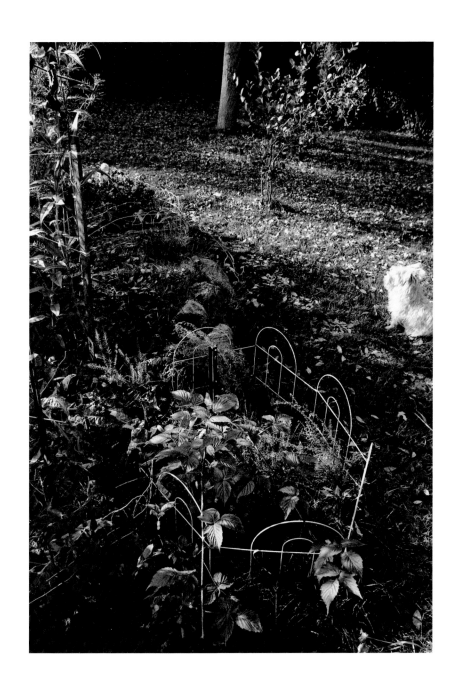

Sally in the backyard, 1990

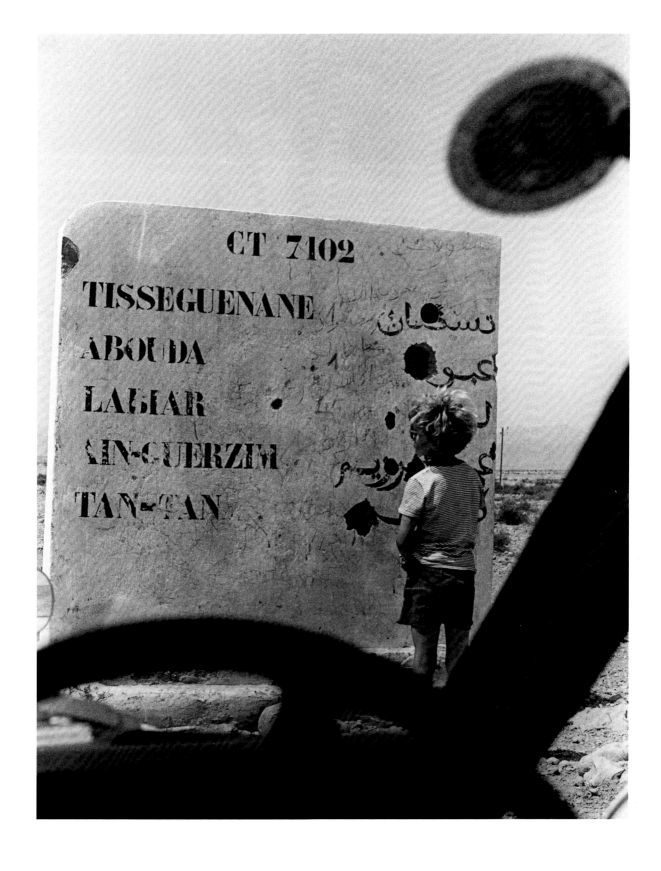

CT 7102
TISSEGUENANE
ABOUDA
LABIAR
AIN-GUERZIM
TAN-TAN

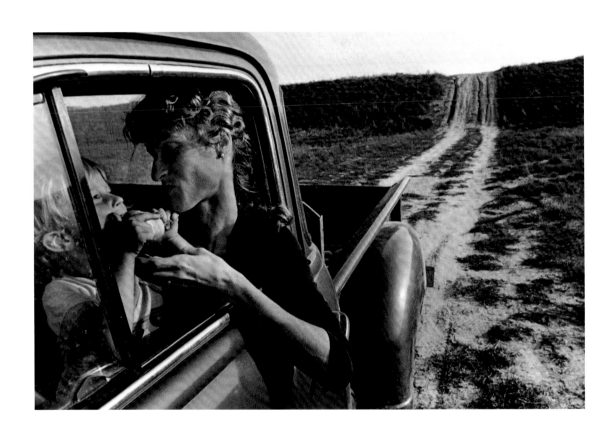

Larry Towell *My oldest son Moses Towell eats a wild pear while sitting with my wife Ann behind the wheel of the family pick-up truck, Lambton County, Ontario,* 1983

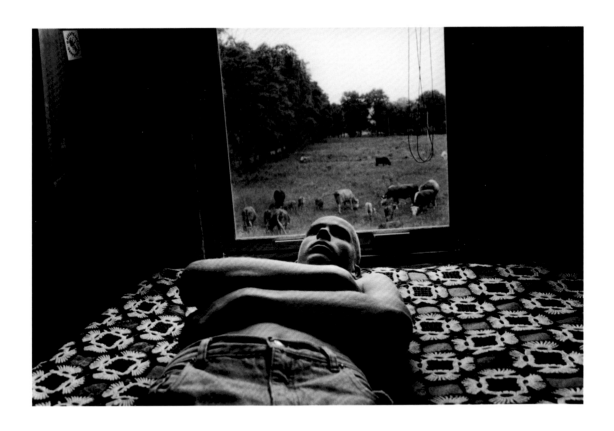

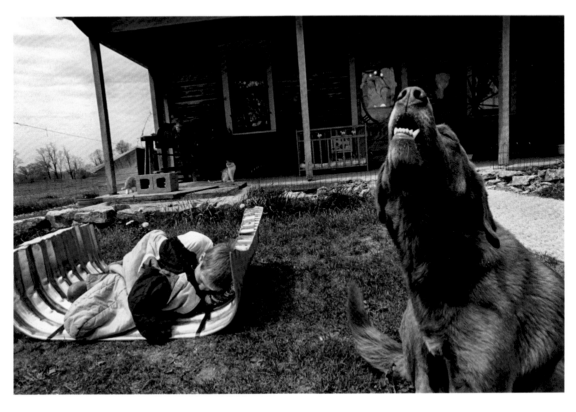

Moses Towell after his friend shaved his head, Lambton County, Ontario, 1995. My son, Noah Towell, who has a fever,
lying in front of the house in the spring season. His dog Banjo is barking, Lambton County, Ontario, 1995

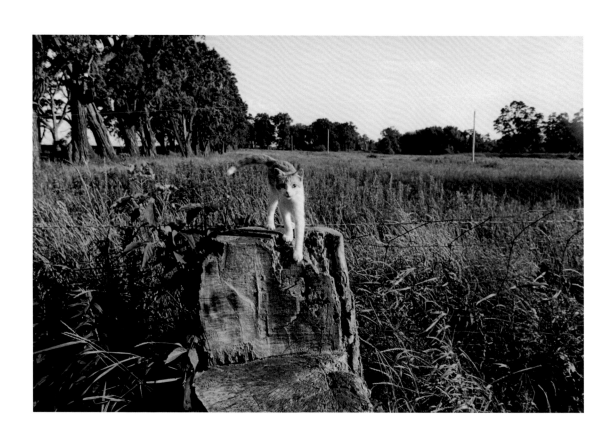

One of the Towell cats on a maple tree stump in front of the cow pasture, Lambton County, Ontario, 1995

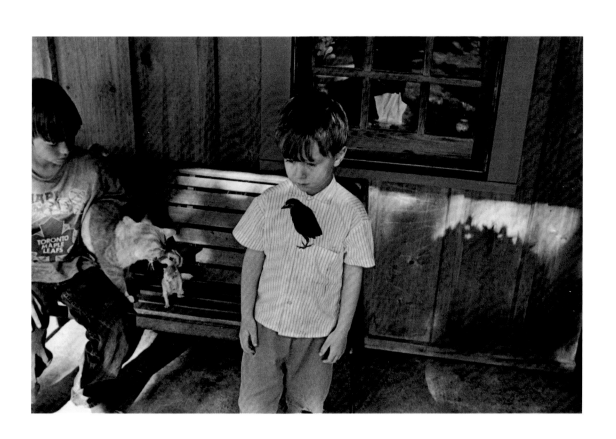

Noah Towell and his brother Isaac on the front porch, Lambton Country, Ontario, 1999

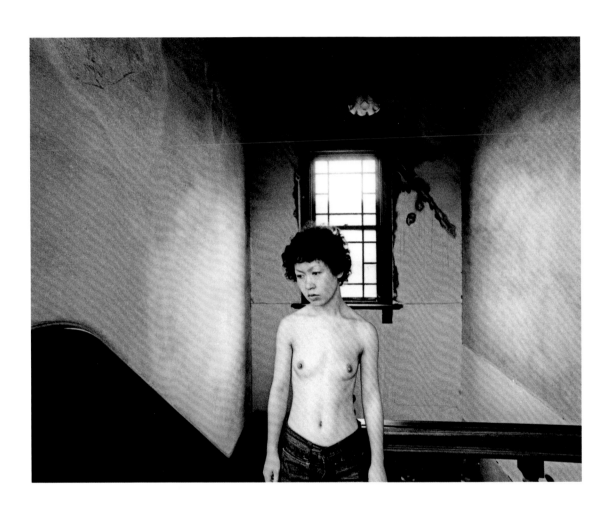

Nobuyoshi Araki photographs from SENTIMENTAL JOURNEY, 1971

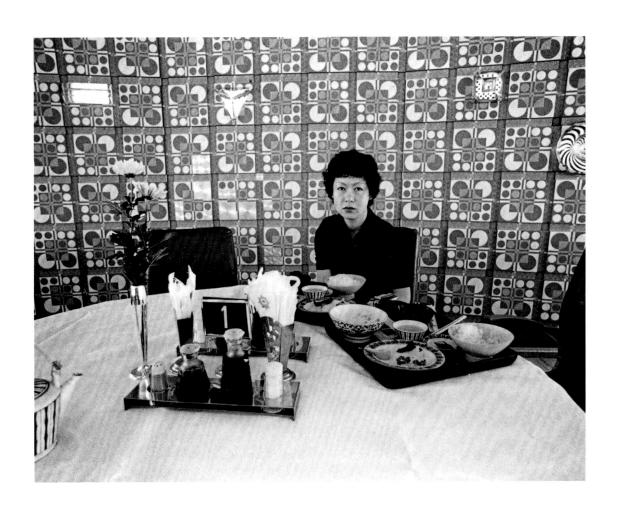

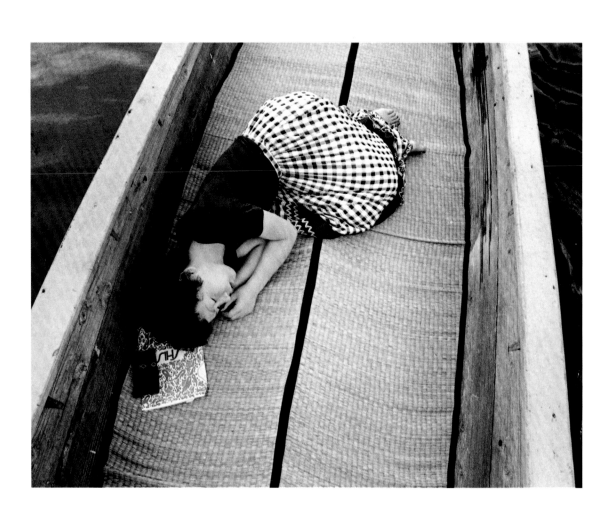

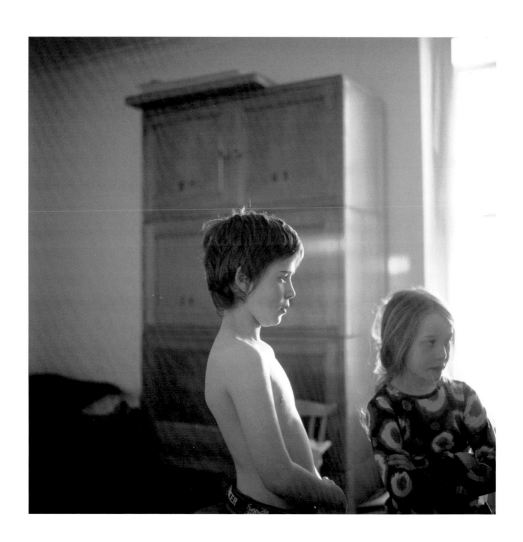

Toby Glanville *Samuel and Bella*, 2003

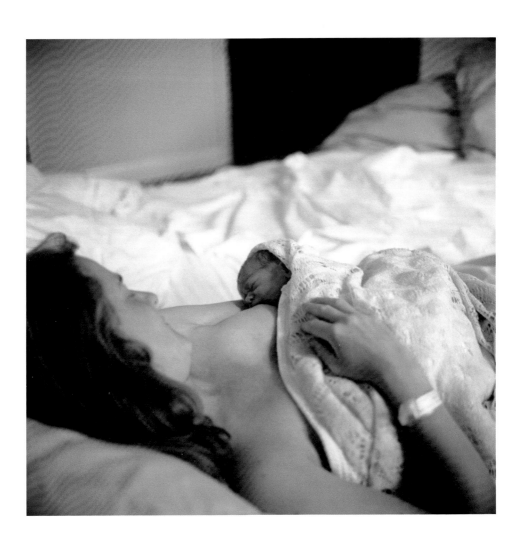

Lucinda and Samuel, 23 June 1993

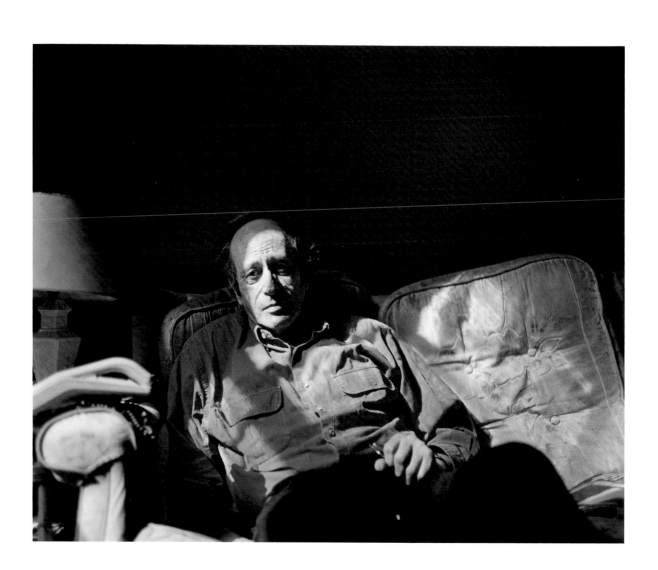

My father, 2003

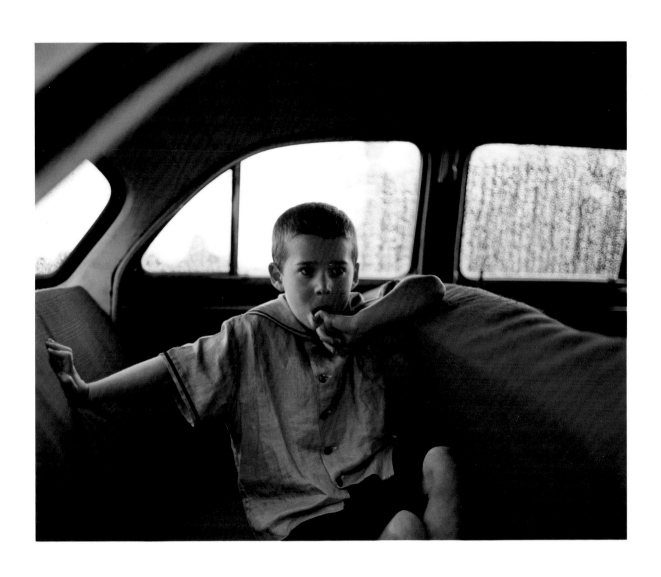

Samuel, 1999

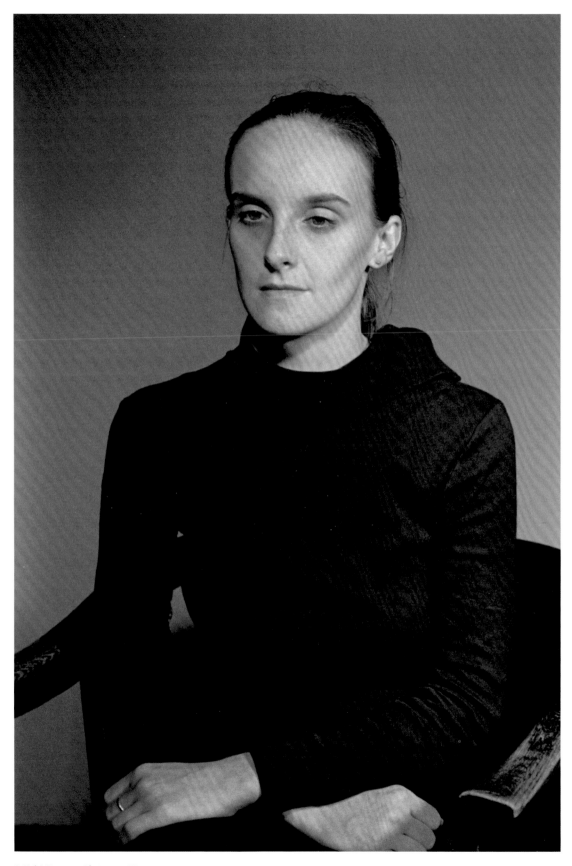

Seiichi Furuya *Christine, Wien*, 1982

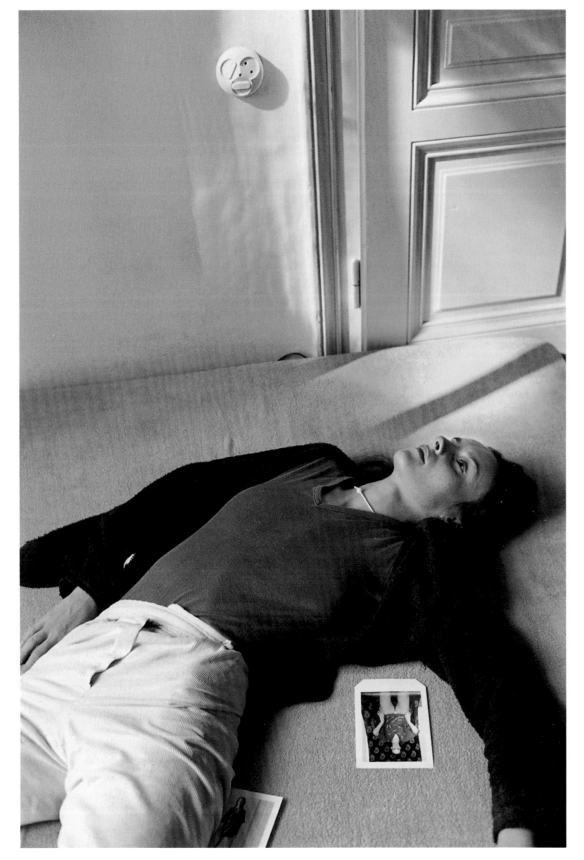

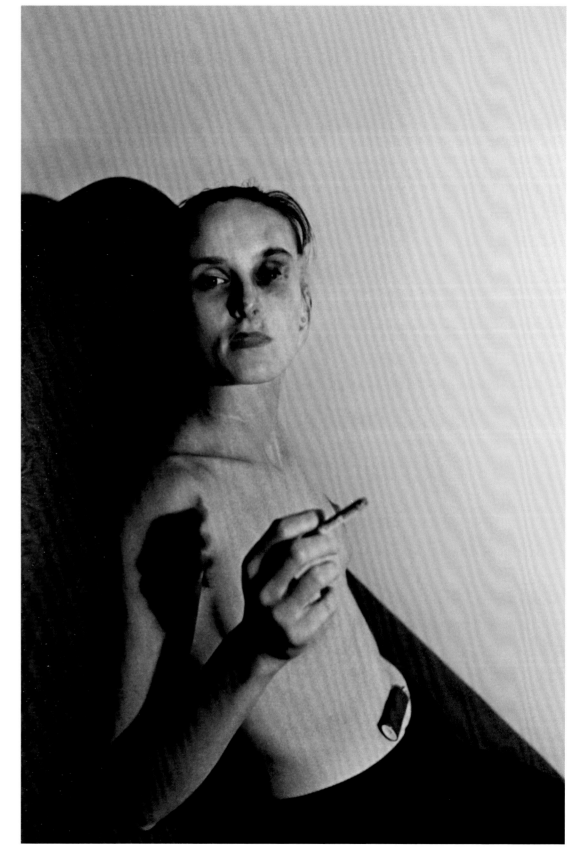

Christine, Wien, 1982

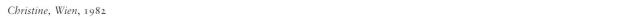
Christine, Wien, 1982

Shane Gilliver *Nanci, June* 2002

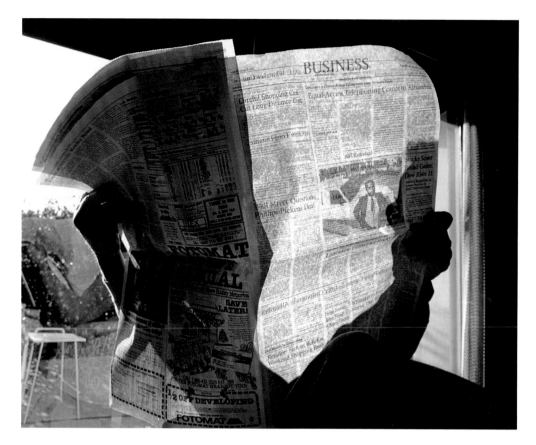

Larry Sultan *Christmas morning, 1985. Thanksgiving, 1986*

Conversation through the kitchen window, 1988

Nan Goldin *The Parents at a French restaurant, Cambridge, Mass.* 1985

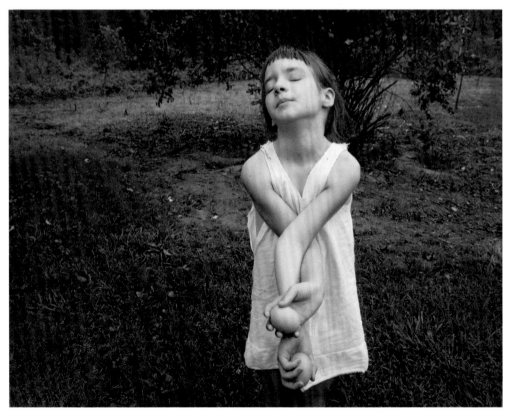

Emmet Gowin *Barry, Dwayne and Turkeys, Danville, Virginia*, 1970. *Nancy, Danville, Virginia*, 1969

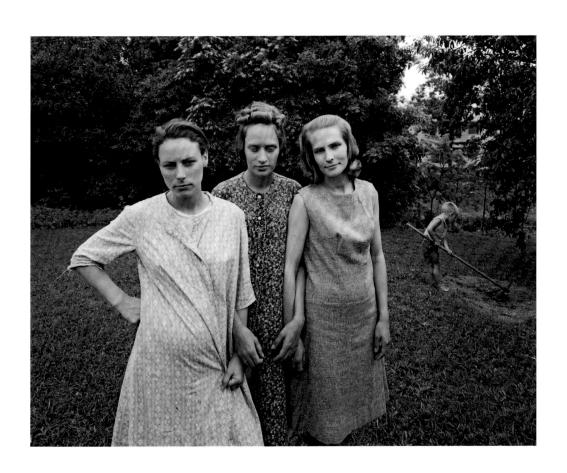

Edith, Ruth and Mac, Danville, Virginia, 1967

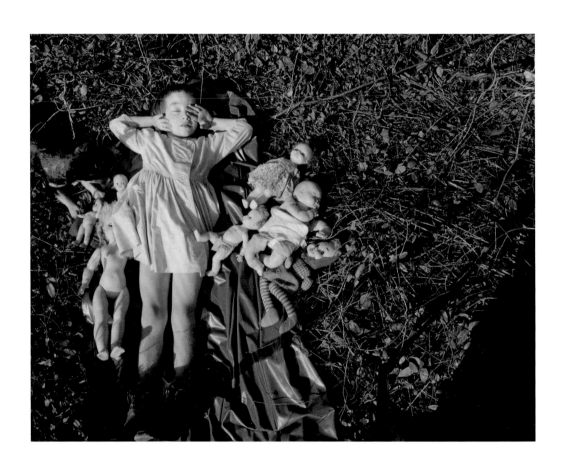

Nancy, Danville, Virginia, 1967

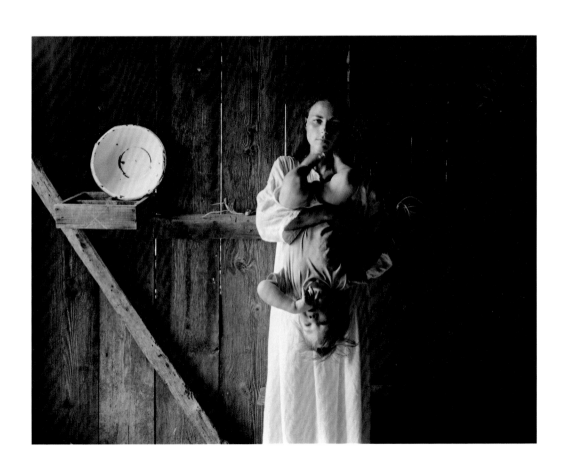

Edith and Elijah, Danville, Virginia, 1968

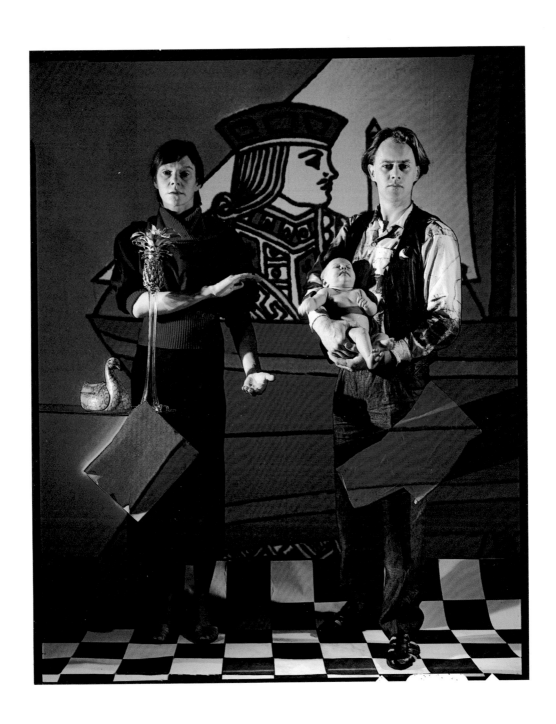

David Buckland *The Jack*, 1984

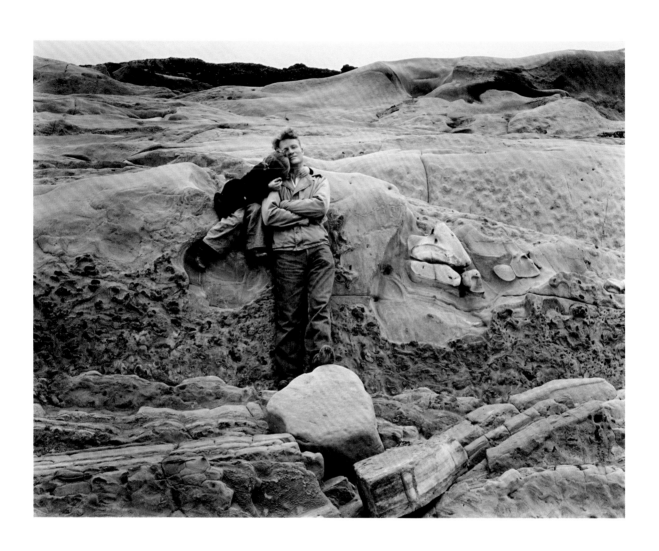

Edward Weston *Brett and Erica*, 1944

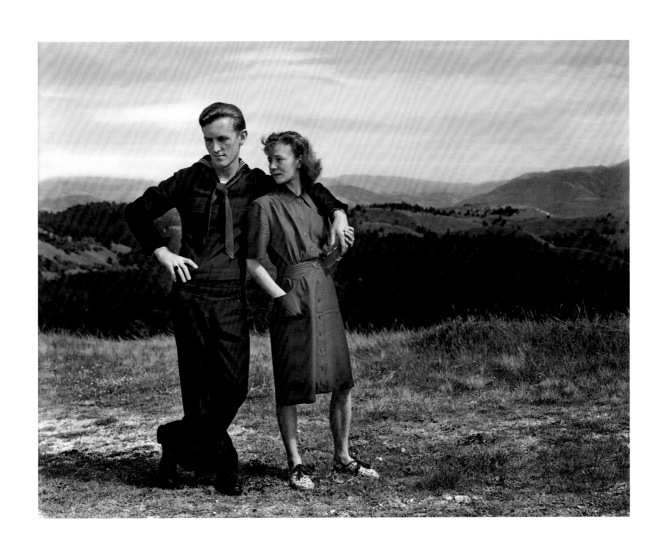

Cole and his wife Dorothy, 1945

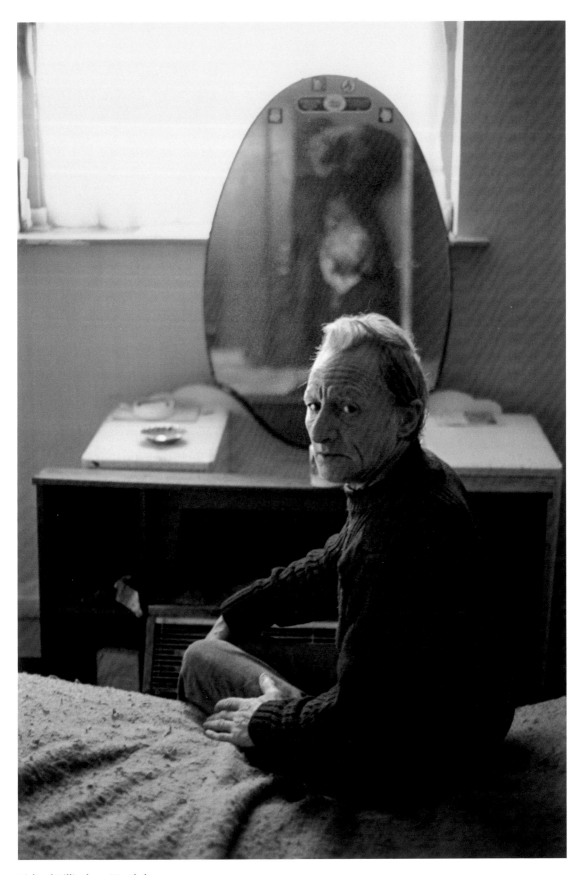

Richard Billingham *Untitled*, 1990

Sally Mann *The Alligator's Approach,* 1988

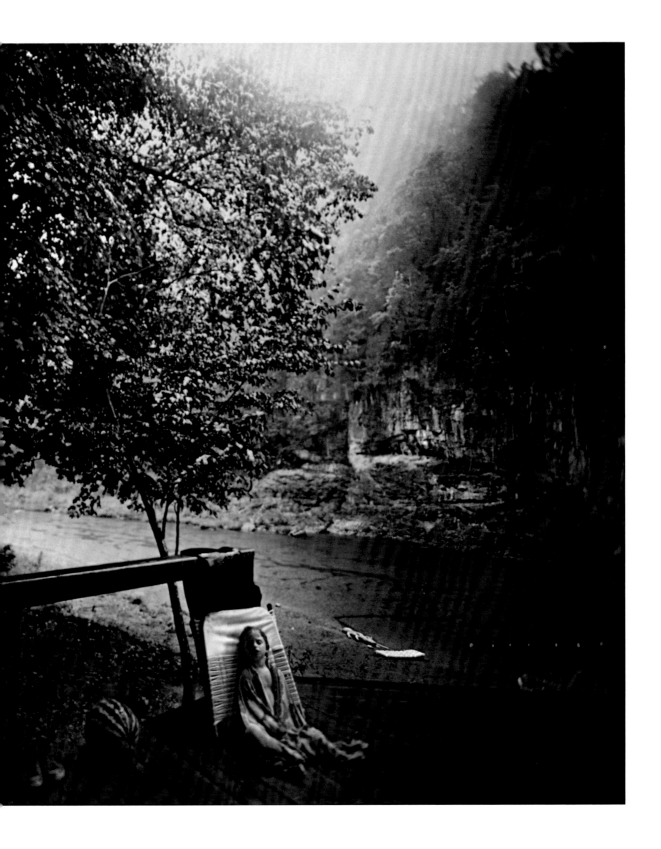

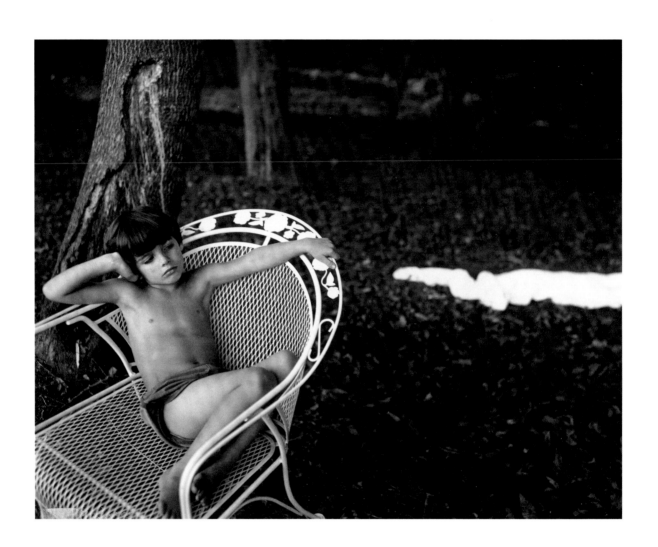

Emmett, 1985

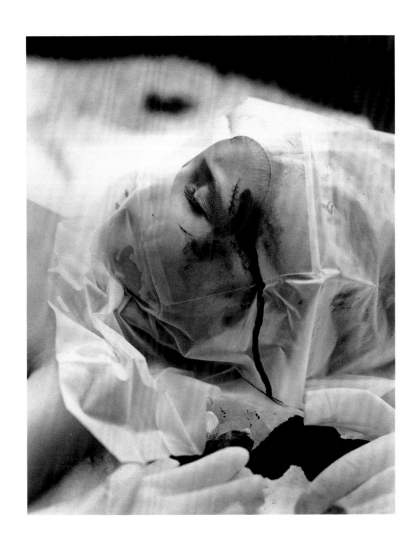

Jessie's cut, 1985

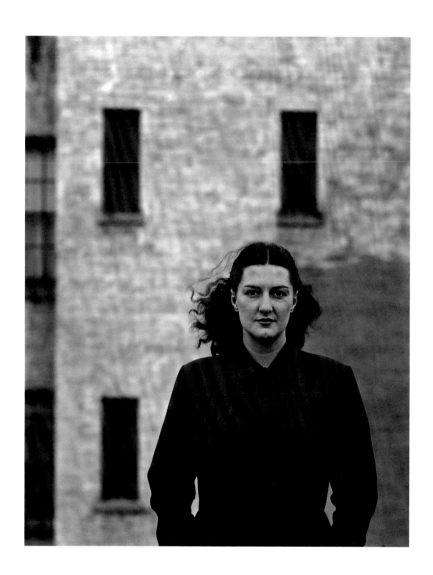

Harry Callahan *Eleanor*, 1945

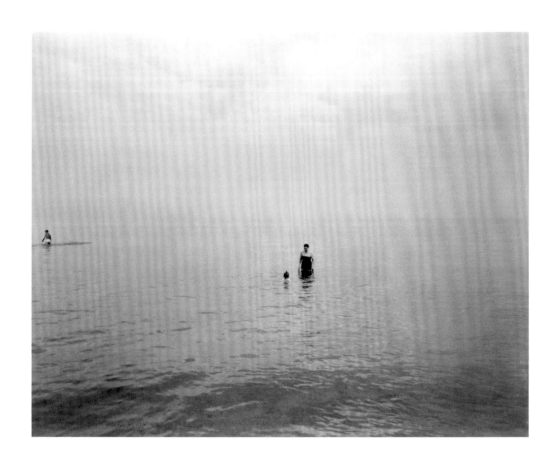

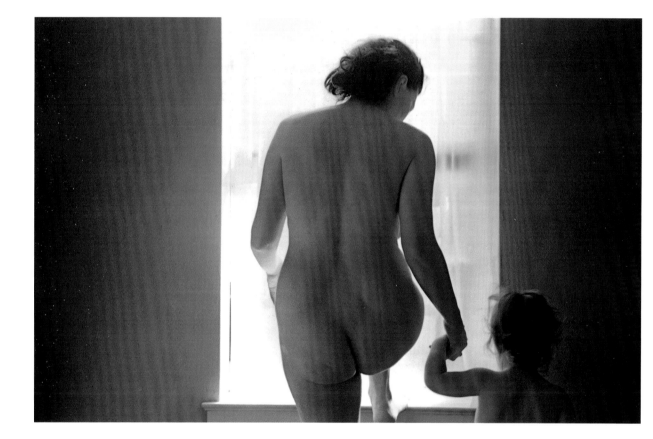

Eleanor and Barbara, Lake Michigan, 1953

Eleanor and Barbara, Chicago, 1953

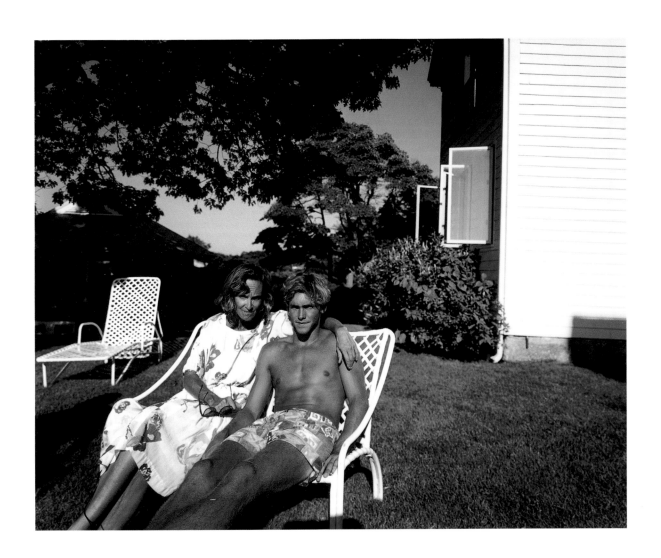

Tina Barney *Tim and I*, 1985

173

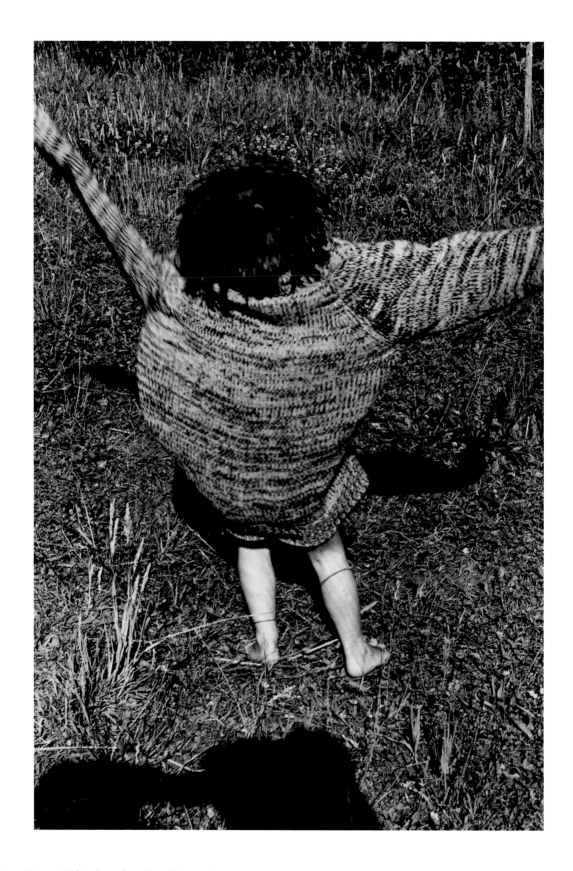

Roger Mayne *Katkin dressed up, Rose Cottage, Dorset,* 1970

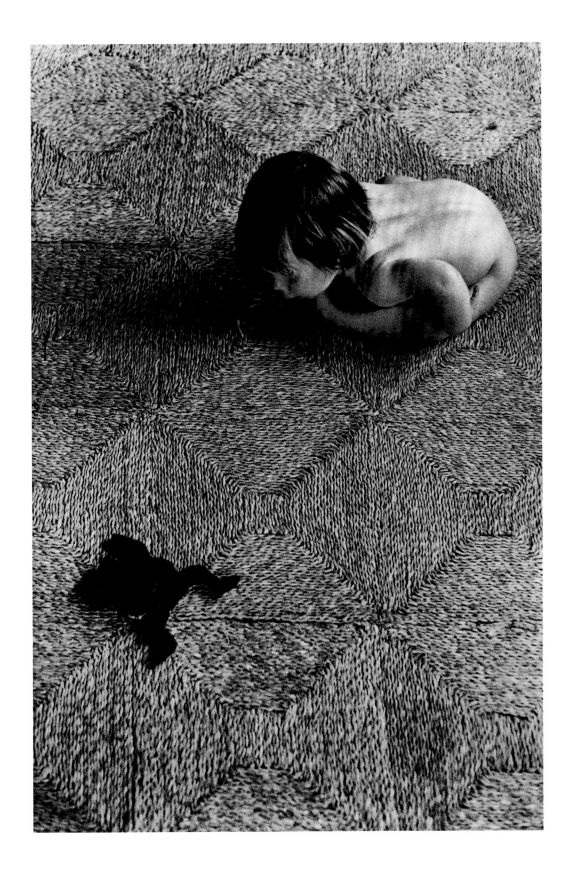

Tom and frog, Rose Cottage, Dorset, 1970

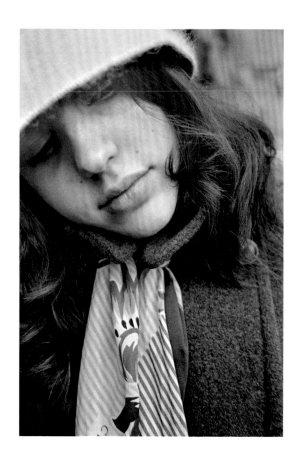

Harry Gruyaert *Saskia, Venice*, 2001

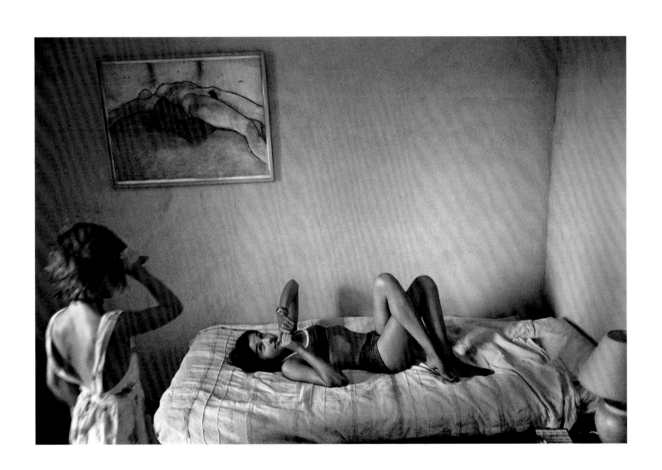

Saskia and Marieke, Malaucène, 1999

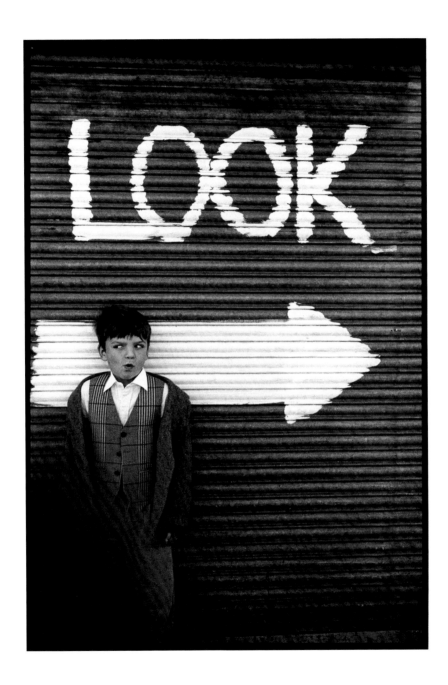

David Bailey *Sascha*, 2001

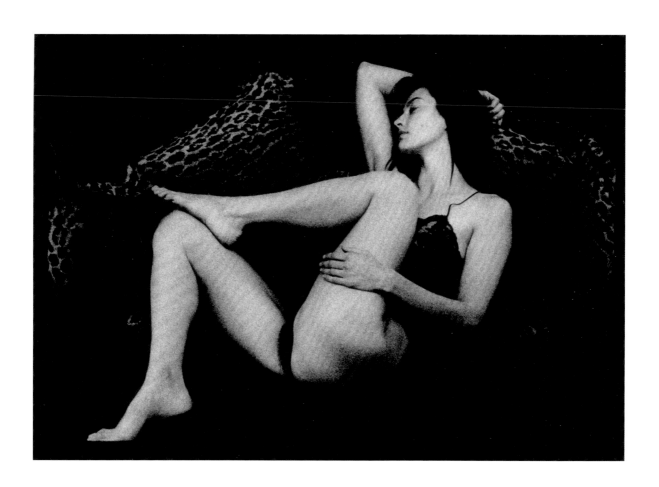

Catherine Bailey, 1990

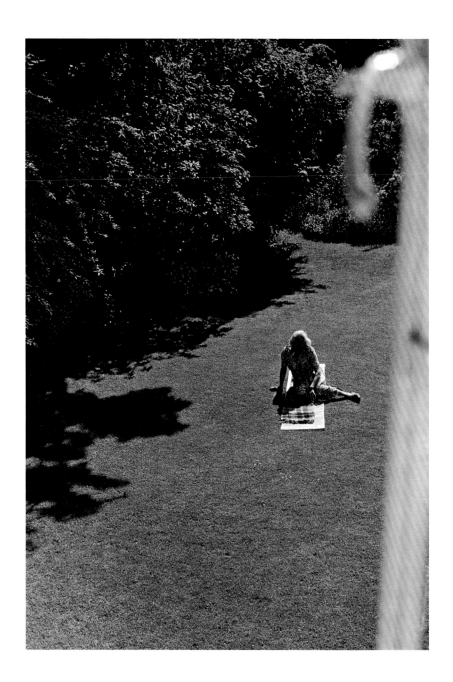

Paddy Summerfield photographs from MOTHER AND FATHER, 1996–2002

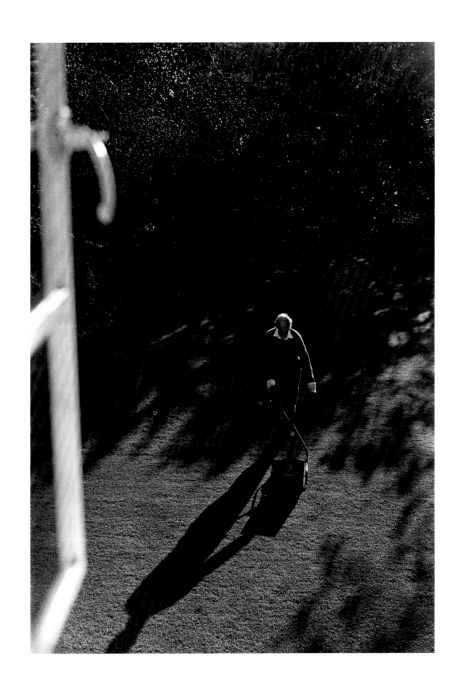

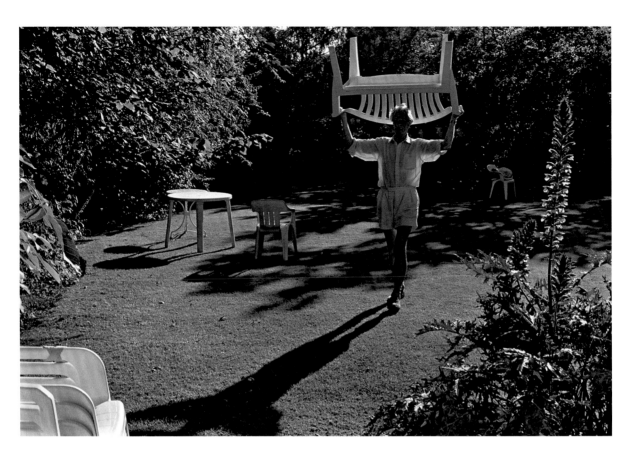

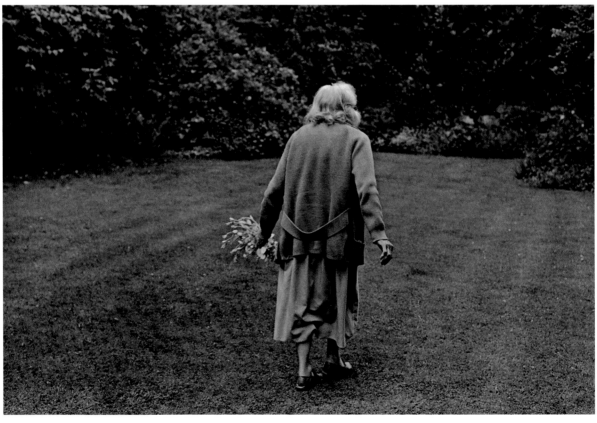

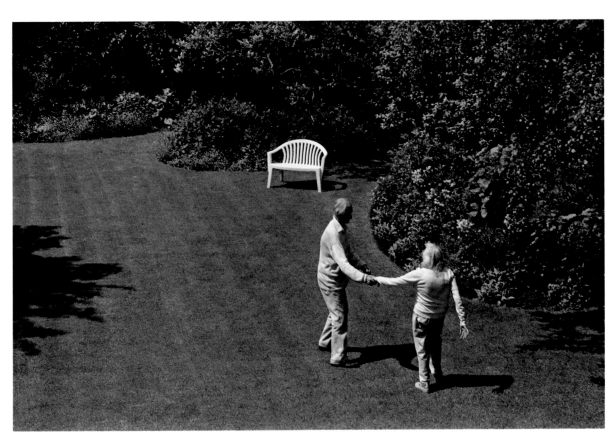

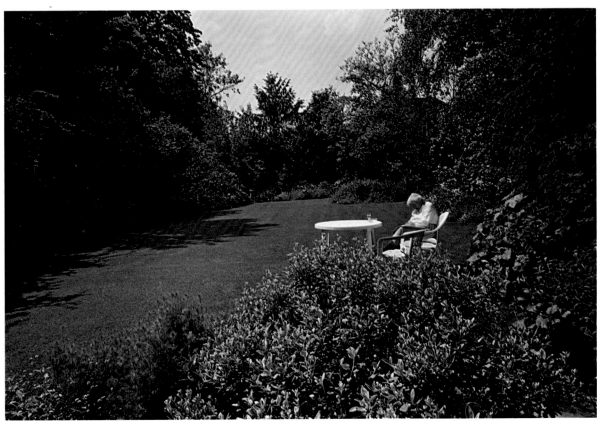

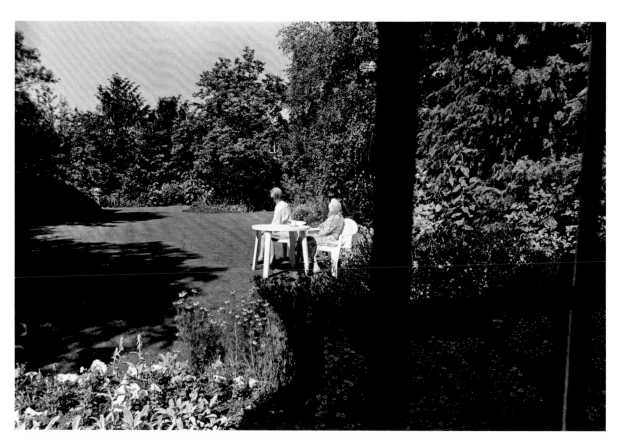

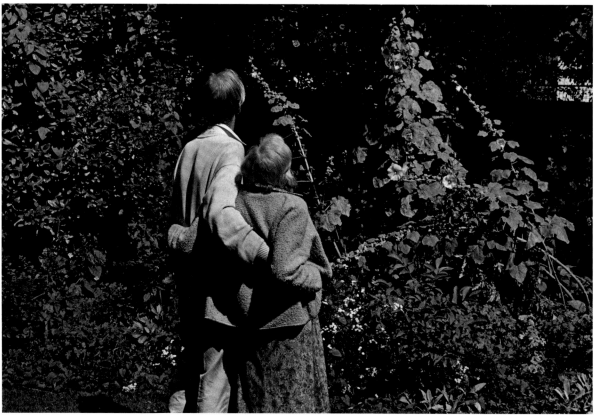

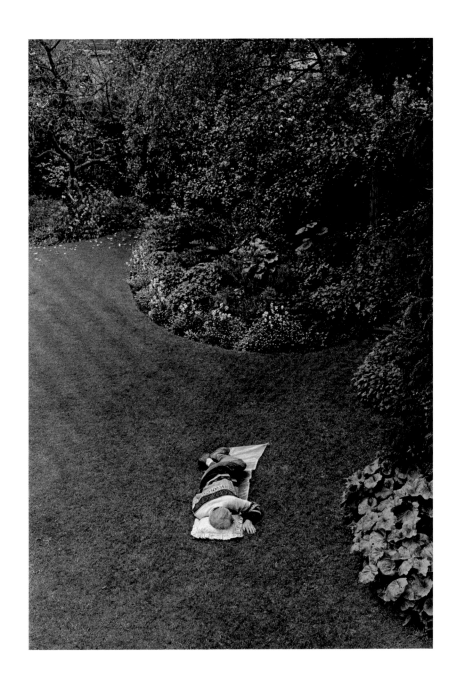

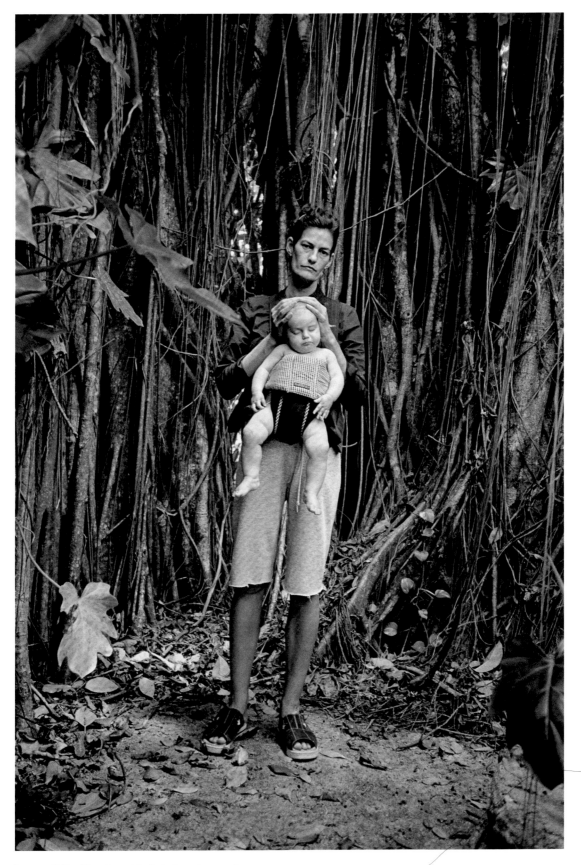

Juergen Teller *Venetia and Lola in Jamaica*, 1998

James VanDerZee *Road to Home*, 1903

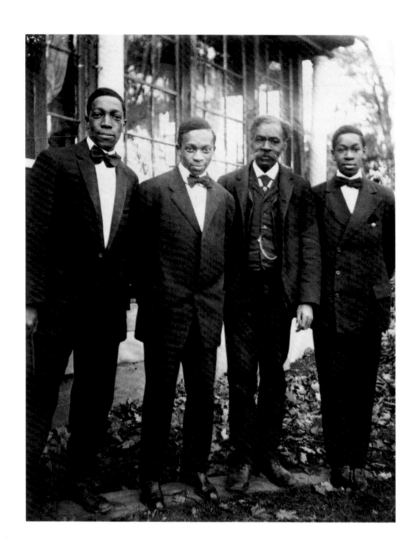

VanDerZee Men, C. 1909

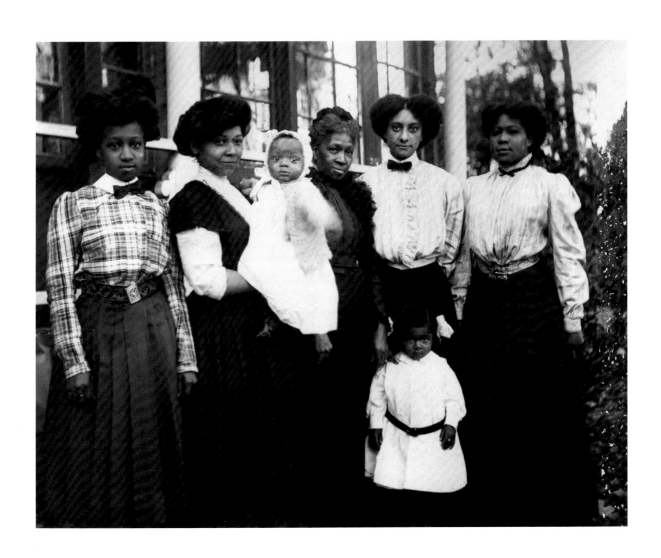

VanDerZee Women and Children, c. 1909

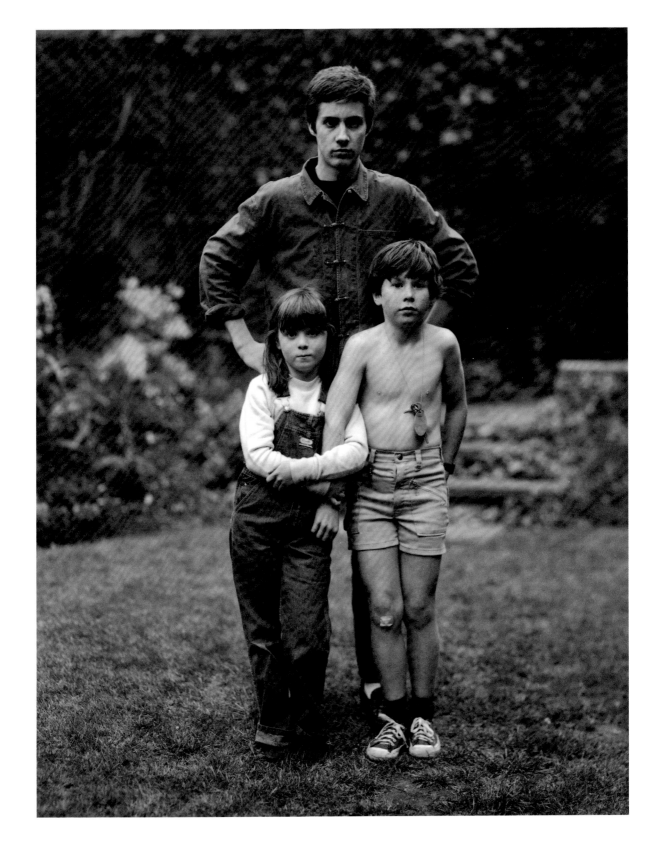

Terence Donovan *Daisy, Daniel and Terry Donovan, Chepstow Villas, Notting Hill Gate, 1970s* 195

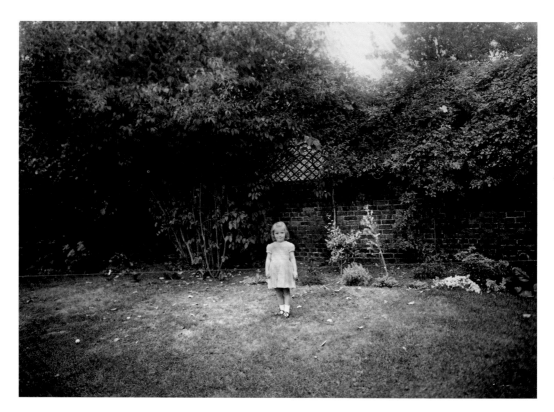

Daisy, Chepstow Villas, Notting Hill Gate, 1970s. *Chepstow Villas, Notting Hill Gate*, c. 1980

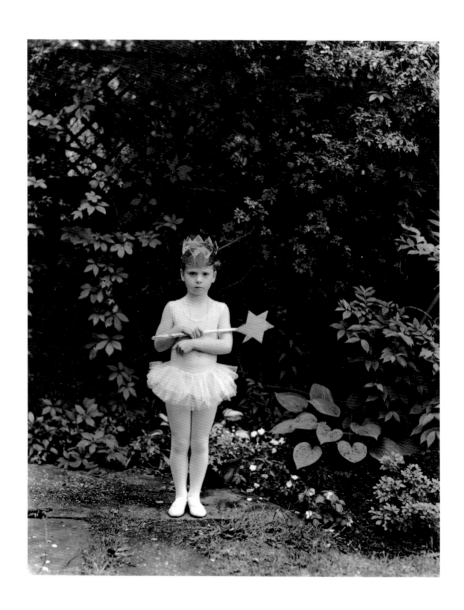

Daisy, Chepstow Villas, Notting Hill Gate, mid 1970s

Notes on the photographs *by Margaret Walters*

Robert Adams
b Orange, New Jersey, USA, 1937

For years Robert Adams has put together a scrupulous – and damning – record of the way big business and the army are permanently damaging the American West. Yet he often returns, literally, to his own backyard. His book *I Hear the Leaves and Love the Light* (1999) affectionately captures life with his wife Kerstin and their small, shaggy white dog, Sally, who might, he admits, have walked straight out of a children's book. His affectionate photographs of Sally are tinged with gentle humour. The dog usually manages to upstage a quietly amused Kerstin. Adams photographs his small urban garden from unexpected angles: mysterious and exciting – as Sally might see it, he suggests. His beautiful images miraculously avoid sentimentality, and it seems entirely appropriate when, in his preface, Adams invokes Kenneth Clark's remark that 'the enchanted garden … is one of humanity's most constant, widespread, and consoling myths'.

Susan Andrews
b Bristol, UK, 1958

Susan Andrews is a professional photographer but finding herself spending time at home after the birth of her second child, her work became more personal. She wanted to go beyond conventional family photos, where everyone smiles in a triumph of hope over fact. When she began photographing her daughter, Lois began suggesting pictures. Sometimes they were things she liked, or was frightened by, or had made (the paper with a string heart and scattered flowers was her first art work.) She collaborated with the camera, discussed the pictures with her mother and felt that they somehow validated what she was seeing and doing. When Lois was seven, Andrews stopped taking so many pictures, feeling that she might be hindering the child's necessary growth away from her. But Lois remains deeply interested in photography; their shared project continues, though without its earlier intensity.

Leonid Andreyev
b Oryol, Russia, 1871. d Kuokkala, Finland, 1919

The Russian writer Leonid Andreyev, who moved with his family to Finland after the Revolution and died there in 1919, was a serious and persistent photographer, a pioneer in the use of Autochromes, early colour slides on glass plates. He made many studies of his family and friends, often paired with frank and revealing self-portraits. The images of Andreyev with his second wife, Anna, bundled up against the cold, seem straightforward and affectionate, and so is his summer self-portrait, in which he is nude – daringly intimate for his time – and proudly holding his baby son. But we always sense the photographer's presence, perhaps particularly in the intriguingly remote shot of his mother, curiously inaccessible as she looks through a window across pot-plants and tangled bushes. Andreyev also made disturbingly honest, self-revealing images of his sons by his first marriage, which seem to acknowledge their distress after their own mother's death and their father's remarriage.

Jules Antoine
b Limoges, France, 1863. d Paris, France, 1948

Jules Antoine, a Parisian architect and art critic, began photographing his family in the 1890s. He used a slow, large-format camera, but his images are intimate, often tenderly revealing. Many of them are of his two children, sometimes alone, sometimes with his wife Pauline, occasionally with himself, his arms protectively around them. The family had obviously learned to live with his ever-present camera; in one particularly intriguing photograph of Pauline and the children, they pose against a wall on which he had pinned a group of his portraits of them. He sometimes took pictures on an ornate iron balcony of the house – portraits of his daughter Marthe, still youthfully vulnerable, and of his son Jean. But after Jean died suddenly in 1921, Antoine put away his camera and never took another photograph. His negatives were discovered fifty years later by his great-grandson.

Nobuyoshi Araki
b Tokyo, Japan, 1940

Nobuyoshi Araki has published over 300 books (still counting). To western eyes, his images of bondage and his, apparently, hard, cold view of women's bodies can be disturbing. However, his position as a highly influential post-war Japanese photographer is undeniable. Perhaps his most important, certainly his most moving, work centres on his wife, Yoko. *Sentimental Journey* (1971), a 'diary' of his honeymoon, contains some troublingly cool and explicit images, but it develops into a quietly domestic and tender personal record. The photographs dwell lovingly on Yoko's delicate body, recording her increasing fragility. They take on added poignancy because, after a long illness, Yoko died. Araki's most haunting image shows her curled up, asleep in a boat; in retrospect, he says, she seems to be beginning 'the journey to death, to the other world'. This picture, Araki has said, 'taught me that photographers have to love their subject'.

David Bailey
b London, UK, 1938

David Bailey became famous in the 1960s, mainly for his fashion photography; but, as he remarked, he didn't die in 1969. He has remained active as a photographer, while extending his range of work to include video, most notably a collaboration with Damien Hirst that was titled *Fourteen Stations of the Cross*. In this photograph his wife Catherine, wearing brief black underwear and leaning against leopard-skin cushions, displays the aplomb and practised sexiness of a professional model. Despite the complicated pose, her elbows and knees making a formal pattern of angles and contrasts, she looks relaxed, at ease, and the photograph can thus be read as intimate rather than simply voyeuristic. The affectionate study of the Baileys' son, mischievously pulling a face, is touching because it has the easy liveliness of a snapshot that any parent might take.

Tina Barney
b New York, New York, USA, 1945

Tina Barney's photographs are an intimate record of family life and a dispassionate documentary about class. Her finest work concentrates on the world she knows best, the metropolitan elite of New York's Upper East Side and Rhode Island. Her photography, she says, is about the people to whom she is closest, but nostalgia for an older, vanishing way of life with 'quality' fuels her attempts to preserve the present moment. Barney's pictures, however personal, are hardly spontaneous; working in colour with a large-format camera, she stages her photographs and directs her subjects. She photographs most of them repeatedly; they 'now feel as if they're collaborating with me'. Her best work – including this tender, but curiously anxious, self-portrait with her adolescent son Tim, from her book

Theatres of Manners (1997) – recreates intimate moments that reveal much about herself, about family relationships and about the privileged class to which she freely admits she belongs.

Richard Billingham
b Birmingham, UK, 1970

Over a period of seven years, Richard Billingham photographed his own family with ruthless honesty; the title of his book, *Ray's a laugh* (1996), is heavily ironic. The family once lived in a small terraced house, but moved to a council tower block after Billingham's father Ray lost his job as a mechanic and blew his redundancy money on drink. The images are unsparing, sometimes shocking: the flat is a squalid mess, Ray is often conspicuously drunk, and the laughter can seem despairing. However, the family seems bound together as much by love as by violence and poverty, and Billingham catches moments of pleasure and tenderness: Ray playing with his dog, his wife poring over crossword puzzles. Acknowledging his family's self-destructiveness, Billingham also celebrates its vitality. This image of the photographer reflected behind his father seems to acknowledge his sense of responsibility in making public these pictures of the vulnerable family he loves.

Vlado Bohdan
b Prague, Czech Republic, 1972

Vlado Bohdan, who lives in Prague, works as a theatre photographer and as a teacher. He has also produced (together with his wife, who wrote the text) a book of images of his son and daughter called *How to Meet Children* (2003). 'I only started to photograph children properly, to really consider them, when I had my own children', he says. This involved exploring his own feelings: 'I found myself in my children. And I found them in myself.' Yet the children remain, he adds, mysterious, something he suggests in these remarkable and troubling pictures: his son holds a blank plastic mask in front of his face and his daughter peers up through a feathery carnival mask. Children 'are our hope, our joy, our worry', he remarks, and, as these photographs hint, reminders of our mortality.

Edouard Boubat
b Paris, France, 1923. d Paris, France, 1999

In 1947, Edouard Boubat, a French photojournalist, met Lella, a friend of his younger sister, and immediately fell in love. They married, and the beautiful Lella became his model; he put together a book about her, a series of exquisite and loving studies in different poses and places. The most famous photograph, certainly the most powerfully sexual, was taken in Brittany in 1947. Lella has been compared to Helen of Troy: she gazes into the distance – her lovely face stern and preoccupied – her transparent white shirt clings to her body, revealing her black bra. This image, which provides an intriguing contrast, was taken a year later in Paris. Lella stands on the Pont des Arts, neatly dressed, her hair piled on top of her head, carrying what looks like an artist's portfolio. Is this the 'real' Lella? Or are the pair once more collaborating to create a tantalizing image – a still from a movie, a fiction?

David Buckland
b London, UK, 1949

David Buckland is noted for his dramatic portraits, usually of couples, and often of himself and his wife Siobhan Davies, a well-known contemporary dancer. Buckland has worked as a photographer and set-designer for many dance companies, including Ballet Rambert and London Contemporary Dance, so the theatricality, of his portraits is to be expected. He describes his portraits as 'performances', and as one critic has remarked, his vision is of life as spectacle. He has taken many exquisite black-and-white nude photographs of Siobhan dancing. Their re-staging of van Eyck's painting *The Arnolfini Marriage* (1434) verges on parody, but the theatricality is neither false nor frivolous. Buckland's photographs are sharply observed depictions of individual character, relationships and class mores. This image of himself and Siobhan with their baby Piera against a blown-up image of that 'wide boy' the Jack, at first glance disconcertingly stagy, is also touchingly personal.

Harry Callahan
b Detroit, Michigan, USA, 1912. d Atlanta, Georgia, USA, 1999

Like many American modernists, the Chicago photographer Harry Callahan composed his pictures precisely and formally, even when he took his wife Eleanor and daughter Barbara as subjects. This is not to suggest that the Callahans' marriage was anything but close and mutually dependent; he has said that he would have felt too self-conscious working with a professional model. But his pictures – Eleanor posed in front of a tower that frames and dwarfs her; Eleanor and Barbara as tiny, hardly recognizable figures lost in the vastness of a misty Lake Michigan – are not so much family studies as coolly detached exercises in abstraction. Callahan's work seems to have changed, only becoming truly intimate, when he used a small camera and returned to colour. Eleanor is transformed: the black-and-white goddess becomes a human being, a solid, fleshy and beautiful woman, who tenderly takes her daughter's hand.

Julia Margaret Cameron
b Calcutta, India, 1815. d Kalutara, Sri Lanka, 1879

In 1864, when Julia Margaret Cameron was forty-eight years old, she was given her first camera, immediately fell in love with its possibilities, turned an old hen coop into a makeshift studio, and began taking photographs. Her immediate family, her servants and friends who visited her on the Isle of Wight were all pressed into photographic service and were often left to fend for themselves. Her work is, in one sense, profoundly and movingly domestic. But she was not only interested in making straight portraits; her models were usually transformed and idealized, presented as Biblical or classical figures, or as personifications of virtue. These four small, lovingly precise, and touchingly personal images of her sleeping grandson are as near as she comes to the realism of daily domestic life. But even these seem to be studies that prepare for her more famous pictures depicting religious scenes, like this exquisite composite of the Madonna (one of her favourite models, Mary Hillier) bending tenderly over the sleeping Christ.

Elinor Carucci
b Jerusalem, Israel, 1971

'My mother was the first person I ever photographed', remarks Elinor Carucci, 'and I still take pictures of her obsessively'. She started when she was fifteen, with an old camera of her father's, though her interest soon

extended to the rest of her family and later to her husband. She admits that she still 'measures' her own femininity against her mother's. Using the camera, she says, has helped her both to separate from the older woman and to stay in touch – her mother has even referred to the camera as another child. Carucci's book of family photographs, *Closer* (2002), explores some of the ambiguities that are inevitable in family relationships. Many of her images are tender celebrations of an easy, loving intimacy between her parents and their children, between her brothers and sisters. But other startling close-ups – of a heavily lipsticked mouth, for example – seem to acknowledge that intimacy is sometimes disturbing.

Gautier Deblonde
b Rouen, Normandy, France, 1969

The French portrait photographer Gautier Deblonde has been living in London for thirteen years, mainly working for the press. He has published several books, the most recent of which contained a series of photographs taken during the filming of Lynne Ramsay's *Morvern Callar* (2002). Although most of his work is still in London, since the birth of his first child, he inevitably spends more time at his home in France with his wife Bénédicte. This tender photograph of Bénédicte was taken not long before she gave birth and the picture of their son, Victor, was taken just hours after he was born. When talking about this picture Deblonde expressed his feelings of enormous love, but also anxiety: did he love him enough yet? had he made a real connection with him? These moving family photographs acknowledge, and perhaps begin to celebrate, the realization that from the moment of Victor's birth their lives had been changed forever.

Raymond Depardon
b Villefranche-sur-Saône, France, 1942

Raymond Depardon grew up on a farm near Lyons and as a teenager began to photograph, first the cats, then the other animals on the farm, moving on to his family, the farm and its workers. In 1958 he went to Paris, became a professional photographer, and worked abroad, in Vietnam and particularly Africa. But he always returned to the farm, photographing it both with the affection of a family member – in colour it can appear idyllic – and the detachment of an outsider. In 1995 he put together the book, *La Ferme du Garet*, which combines old black-and-white snapshots of the family and farm, bleak but tender images of his ageing parents, examples of his own professional work, and affectionate photographs of his nieces and nephews playing. Depardon's work is about memory, of his own past and of a world that is passing away.

Joëlle Dépont
b Casablanca, Morocco, 1951

When she was a child in Morocco, Joëlle Dépont's father took constant snapshots of his family; she remembers enjoying the attention, and still treasures his old pictures. She grew up to become a photographer herself, living in several different countries and keeping a personal photographic 'diary' of family, friends, and the places in which she has lived. Her life changed when she decided to stay at home and look after her only child, Max. Taking photographs of Max took on, she recalls, great significance. It was a way of reminding herself that she was an accomplished professional who loved her work; at the same time, it revived memories of her own childhood, and her father's pictures. Max, she says, is relaxed in front of the camera, seeing it as a special bond with his mother. However, there are times when he does not want to be photographed and

Dépont is reminded of the 'unspoken agreements' involved in photographing family members.

Terence Donovan
b London, UK, 1936. d London, UK, 1996

Donovan, along with David Bailey and Brian Duffy, was one of the young photographers whose fashion and advertising work – glossy, sexy, self-consciously modern – summed up the myth of the 'Swinging Sixties'. That fantasy, always fragile, proved short-lived; fashion by definition demands a restless search for novelty and Donovan was amongst the first to take glamour pictures out into unglamorous settings. But, as a 1999 retrospective revealed, his work was varied; in the early sixties he did a powerful documentary series in the East End of London. These affectionate images show his own family in their leafy Notting Hill Gate garden: Daniel, the son of his first marriage, and Terry and Daisy, his children with his second wife. In one photograph Daisy poses, self-conscious and solemn, in her fairy costume. The images are tender and intimate, moving because they are so straightforward. They take on retrospective poignancy from Donovan's tragically untimely death in 1996.

Lee Friedlander
b Aberdeen, Washington, USA, 1934

'Give me anybody's family album and I'll find lots of interesting pictures', Lee Friedlander once remarked. Best known for his work in the documentary tradition, and for a famous and beautiful series of nude studies, he has always photographed friends and family, and since the 1960s has been making an intimate record of his long and loving relationship with his wife. After thirty years, he says, he is still 'curious' about Maria, celebrating her beauty and tenderly acknowledging the signs of age. She is mostly depicted alone, although there are some engaging photographs of her with their children. Maria has obviously learned to relax in front of his omnipresent camera – he photographs her in bed or breast-feeding her baby – but at times she betrays a quizzically amused awareness of its presence. Occasionally, Friedlander includes himself in the photograph. However, there is a sense, he says, in which 'I'm there in all of them.'

Seiichi Furuya
b Shizuoka, Japan, 1950

Seiichi Furuya and his wife Christine were together for seven years; their son was born in 1981. In 1985, after being hospitalized several times for severe depression, Christine killed herself. Furuya photographed her throughout their time together, and the series slowly turns to tragedy as he records, helplessly, the serenely beautiful woman of the early pictures retreating into private darkness. These black-and-white photographs capture her terrifying inaccessibility, but also – in the picture of her smoking – an angry defiance that seems central to her illness. The colour picture, ironically, is the saddest of all: Christine lies flat, staring into space, a few photographs laid carelessly at her side, as if she were foreseeing, acting out, even willing her own death. Was it a painfully learned detachment that made it possible for Furuya to take these photographs, or are they an attempt to reach and awaken her?

Shane Gilliver
b Goldthorpe, UK, 1969

Shane Gilliver has been photographing his young daughter Nanci for nearly five years. The pair usually plan the pictures carefully, deciding together on the setting and the 'story' they will try to tell. This particular day, things were not going well: the light seemed harsh and glaring, and they were about to give up. But Nanci suddenly yawned, and her father managed to capture the moment. When Gilliver wanted to make sure of it by taking a second picture, they were, understandably, unable to mimic the moment, which serves as a reminder that chance can play a crucial part in making an interesting photograph. This is a funny, affectionate image but also an ambiguous one. Taken out of context, it would be easy to interpret the yawn as a scream, whether of fury or fear.

Toby Glanville
b London, UK, 1961

The British photographer Toby Glanville does not always photograph his children when they are together, because his camera, in a sense, separates him from them. At other times the children themselves may be resistant to the process, perhaps feeling that something is expected of them. Many of his photographs are therefore opportunistic, not planned or posed, but 'attempts to record the nervous energy' of a particular moment or exchange. The photograph of his son Samuel sitting in a car is paired with a portrait of his father: the spread, Glanville says, is about three generations, with himself the invisible link. The more recent photograph of Samuel with his sister Bella, paired with an earlier picture of the new-born Samuel and his mother, reminds us of the inherent poignancy of photographs – they enable us to look back on our lives.

Nan Goldin
b Washington, DC, USA, 1953

In her best-known work, *The Ballad of Sexual Dependency*, a slide show and book published in 1986, Nan Goldin created an exuberant visual diary – sometimes funny and hedonistic, often darkly pessimistic – of her life as a young independent woman. It adds up to a record of the wider 'family', which, as so many of us must, she has discovered and created for herself; one, she claims – a shade optimistically in face of the violence of some of the images – is 'without the traditional roles'. But Goldin also admits that she is haunted by the suicide of her older sister; and she includes this powerful and ambiguous portrait, *The Parents at a French Restaurant*, in the book. Goldin's cool, ironic detachment – her father's tie echoing the upholstery, her mother's clenched hands – is tempered with tenderness, unwilling perhaps, but nonetheless real. She acknowledges her own complicated feelings, as well as the old couple's weariness, the tension between them, and their uneasiness at being confronted by their daughter's camera.

Emmet Gowin
b Danville, Virginia, USA, 1941

The Virginian Emmet Gowin's favourite subject is his family, and he creates images, at first glance tenderly affectionate, which can prove unexpectedly troubling. In 1966, when he met Edith, who became his wife and favourite model, his work changed, achieving what has been described as 'snapshot intimacy'. Edith is often portrayed as an earth mother; in Gowin's most startling image, she stands, romantically back-lit, legs apart and skirt held high as she urinates. Caught here with her sisters, the pregnant Edith looks tired, even sullen. In another picture she clutches her baby son Elijah upside-down – perhaps playfully or aggressively – re-enacting his birth. Gowin's work is no simple celebration of fertility or childhood innocence. One of his nephews, collecting turkey eggs, looks miserable; the small Nancy, arms curiously twisted as she holds the eggs, seems lost in some private ritual. The disconcerting shot of Nancy on the ground surrounded by dolls is surely death-haunted, no straightforward celebration of life.

Colin Gray
b Hull, UK, 1956

Colin Gray has been photographing his parents for twenty-two years and is now, he admits, almost as old as they were when he began. Sometimes, looking in the mirror, he sees his father's face. Much of his work is in the directorial mode, staging ambiguous charades and fantastic, even surreal, scenes. He describes his pictures as 'enactments of memory and fantasy'; he has been called a 'stage magician', transforming mundane domesticity. The portraits of his parents combine parody, curiosity, empathy with their vulnerability, and a recognition that his own relationship with them is changing. In *Heaven and Hull*, his mother, rigged out in a tutu, is an elderly but touchingly girlish Cinderella, or a good fairy keeping 'the devil' in her husband at bay. Gray's most memorable work is perhaps his simplest: the grim *Life Support*, a hospital bed glimpsed behind a screen, or the tender *Duvet Day*, where his frail father curls up like a baby beneath a brightly patterned quilt.

Robin Grierson
b Sedgefield, Co Durham, UK, 1962

Robin Grierson became interested in family photographs eighteen years ago, when his older brother had a baby daughter and he began taking photographs of her for the family album, which took on a new fascination. Family photos, he feels, 'are an attempt to preserve love and life, to wrap it up in cotton wool so that nothing can damage it'. When married and had his own children, he began to photograph them; he had, he says dryly, a devoted audience, at least in the children's grandparents. His colour pictures are straightforward and affectionate; in photographing his family – his wife and children at the beach, his small daughter running in the garden – he is aware of really *seeing* them. Cramming his own lovely, lively images into albums, he is fascinated by family resemblances which give him a strong sense of continuity – and remind him of his own mortality.

Harry Gruyaert
b Antwerp, Belgium, 1941

Harry Gruyaert is a member of the photographic agency Magnum, well known for his brilliantly expressive work in colour. He often works in advertising and has photographed much abroad. His first vividly colourful book, *Made in Belgium* (2000), is about his home country; *Rivages* (2003) is an exquisite series of seascapes. But, intriguingly, when this master of colour takes photographs of his own family, he prefers using black and white; it helps him, he says, to approach them more directly, to get closer to them, to express his love. The children now recognize what he is looking for, and will comment, 'Dad's going to get his camera now.' There is a playful intimacy about the photograph of his older daughter, Saskia, sprawled on a bed talking to her sister; a formal nude painting on the wall emphasizes – and perhaps complicates – their innocence. The close-up

portrait catches Saskia's innocence and budding sensuality – and her trusting ease in front of the camera.

Mary Kelly
b Fort Dodge, Iowa, USA, 1941

In 1973, in the exciting context of renewed and eagerly experimental feminism, Mary Kelly began a project called *Post-Partum Document* (exhibited in 1976), which proved a revelation. She offered a refreshing take on the concept of maternal love at a time when the image of mother and child, one of the most beautiful themes in Western art, was in danger of becoming hackneyed. Kelly brought the physical details of child-care into the rarefied gallery space, reminders of the sheer hard work involved. She displayed beautifully mounted stained nappy liners and tiny vests, along with records of the baby's feeding schedule and plaster imprints of his hands. The following year she took these tender, fragmentary close-ups – there are a total of twelve – for her *Bathing Series*, part of the work *Primapara*. The project was given a new and intriguing dimension by her invocation of pyschoanalytic and Lacanian theorizing, though that perhaps distanced her work from some of the people who might have responded to it most eagerly.

Chris Killip
b Isle of Man, 1946

Chris Killip is one of Britain's finest portrait makers. The series that first made his name was shot when, after working as an assistant to the photographer Adrian Flowers in London, he returned to his native Isle of Man to make a record of a community under threat, a world that he feared was vanishing. He came back with a superb record of the landscape, along with formal but often unexpectedly tender portraits of the farmers, factory workers and fishermen who make up the indigenous island community, and who can perhaps be seen as his extended family; the book *In Flagrante* was published in 1980. Killip has said that his photographs are about himself as much as his subjects. This quiet and explicitly personal picture shows his own father, his son Matthew, then aged three, 'and their dog Bruno'. Like all Killip's work, its documentary precision, warmed by affection, avoids any hint of nostalgia or sentimentality.

Dorothea Lange
b Hoboken, New Jersey, USA, 1895. d San Francisco, California, 1965

Dorothea Lange began her distinguished career as a portrait photographer, but her most famous work – including the iconic and still painfully moving *Migrant Mother* (1936) – was made out on the city streets and rural back-roads of Depression-era America. Before her death in 1965, she had been planning something deeply personal, 'a little book' centred around a Californian cabin at Steep Ravine that she often visited with her children and grandchildren. The sequence was not simply about 'people having a good time'; it would be, she hoped, a celebration of freedom. Her husband once remarked that 'her whole being was in her work and her relationship with me, and her relations with her family'. Although she died before she could make her book, she left behind photographs that record, with loving clear-sightedness, her children and grandchildren growing and changing. Eight years after her death *To A Cabin* (1973) was published by her friend, the photographer and writer Margaretta Mitchell, with photographs and texts by both women.

Jacques-Henri Lartigue
b Courbevoie, France, 1894. d Nice, France, 1986

Jacques-Henri Lartigue began taking photographs in 1904, when he was a child, and although he continued for seventy years, his work remained completely unknown for half a century. The influential American curator John Szarkowski remarked that by the time he was ten, Lartigue was anticipating the best small-camera work of a generation later. If the portrait of his cousin 'nicknamed Dédé' brings warmth and tenderness to an apparently informal portrait, a year later Lartigue would photograph something as daringly modern as this stunning image of his own collection of toy racing cars. Even Lartigue's photographs of his own family can prove unexpectedly disconcerting, almost surreal. An image of his baby son Dani, posed by a window with a disturbing line-up of dolls that might have emerged from a nasty science-fiction movie, contrasts intriguingly with the photograph, made twenty years later, of Dani lovingly hugging his own baby son.

Sivan Lewin
b Haifa, Israel, 1966

Sivan Lewin's *Portrait* was inspired by Velázquez's *Las Meninas* (1656); or, rather, by Michel Foucault's essay on the painting. Velázquez stands at his easel and, although we cannot see his canvas, we glimpse the king and queen, reflected in a mirror in the background, looking back at the princess and her maids, at the artist or, perhaps, at their own image. Or perhaps they are looking out at us? For Foucault, the image hints at uncertainties in visual representation at a time when paintings were regarded simply as 'windows' on the real world. Lewin, including herself with a camera in the photograph, asks similar questions about seeing and being seen, about 'shooting' – the word might seem uncomfortably appropriate – her own family. Is the camera sometimes intrusive or disruptive? Do photographs reveal, or disguise, intimate family truths? What are the implications of making public images of one's most private relationships? In her series *Things Worth Knowing* (2001) Lewin attempts a different, and even more ambiguous 'portrait' of her dead grandmother, whom she hardly knew, through some of her personal belongings. Lewin was curious about 'inheritance … notions of femininity and glamour and how they might be passed down'. But this close-up photograph of her grandmother's elaborately jewelled watch, arranged with some armbands in a snake-like pattern, proves unexpectedly unsettling, hinting that legacies from our families may prove more complex, more difficult, than we expect.

Markéta Luskačová
b Prague, Czech Republic, 1944

For many years the Czech photographer Markéta Luskačová lived and worked in England. She is best known for her 'street' photography, notably an affectionately perceptive series on London's Brick Lane. For years, both in England and the Czech Republic, she has photographed children – absorbed in play, proudly dressed up for religious festivals, tentatively venturing into a wider world – with warm but unsentimental clarity. These photographs were taken while Luskačová was living in northeast England. Commissioned to do some work in the area, she was promised a child-minder, who never materialized. So she took her young son Matthew with her and she realized that his presence was a very real advantage – no longer a voyeur, she was part of a family, as were her subjects. In one photograph Matthew crawls towards his mother, laughing delightedly into the camera. In another haunting photograph he dozes peacefully in his pushchair while, behind him, older children playfully test their balance and courage as waves crash across a breakwater.

Sally Mann
b Lexington, Virginia, USA, 1951

Sally Mann's large-format photographs of her own children show commonplace things that every mother has seen: 'a wet bed, a bloody nose, candy cigarettes. They dress up, they pout and posture ...'. Her images, deeply affectionate, are no simple celebration of innocence. The children – often naked – seem at times to enjoy an almost paradisal freedom. But as they play and pose, she acknowledges that their seductiveness leaves them vulnerable. And the children play dangerous games: they 'dive like otters in the dark river', or young Jessie hangs naked from a bailing hook on the porch. Images of the children sprawled on the ground or injured such as *Jessie's Cut* seem to recognize the possibility of disaster. In another haunting image, the half-dressed child looks lonely and vulnerable, unaware of lurking violence: a small alligator crawling out of the river. Sally Mann's photography exists somewhere between pastoral idyll and Southern Gothic.

Roger Mayne
b Cambridge, UK, 1929

Roger Mayne is well-known for his series of street photographs of working-class children around Notting Hill and Paddington, which was exhibited, very successfully, at London's Institute of Contemporary Arts in 1956. However, by 1969, losing enthusiasm and with much of that work still unpublished, he was ready for a new, self-appointed, commission. He started keeping an almost obsessive visual record of his own growing family. It began, according to his wife, 'when he was supporting my leg during the second stage of labour and dropped it to take a photograph of our daughter emerging'. From that point onwards, for the next five years, his camera was nearly always hanging round his neck. After that, she says, he stopped, 'as if rearing his own children with tenderness and care had helped Roger to recreate his own childhood and smooth its scars'. There is humour as well as generous understanding in these pictures of Katkin swamped in an oversized sweater, or of the small Tom cautiously investigating a toy frog.

Ralph Eugene Meatyard
b Normal, Illinois, USA, 1925. d Lexington, Kentucky, USA, 1972

In 1950, when his son was born, Ralph Eugene Meatyard bought a camera, went to classes, and began taking photographs. These soon became staged performances; on Sundays, the family went out on Kentucky back-roads, with a trunk full of dolls, mirrors and masks, looking for the right location. A contemporary remarked that Meatyard introduced a touch 'of the unusual into an authentically banal American usualness'. In 1970, he was diagnosed with terminal cancer, and began his troubling series, *The Family Album of Lucybelle Crater* (published as a book in 1974): sixty-four photographs of his beautiful wife Madelyn, wearing a Halloween-style mask, playing a hag whom he called Lucybelle, with friends masked as ugly old men. In a photograph taken in 1972, just before he died, Meatyard swaps clothes and masks with Lucybelle. It has been interpreted as a tribute to Madelyn's role in holding the family together; but surely it has a darker significance – like the whole surreal series – an image of death threatening family happiness.

Abelardo Morell
b Havana, Cuba, 1948

In the 1980s, after the birth of his son Brady, Abelardo Morell – who had previously worked in a black-and-white street photography tradition – turned back to domestic life, and became fascinated by ideas about reality and illusion. Is this blurred, beautiful image of his wife and Brady glimpsed through the glass-panelled door, or reflected in it? Morell contrived visual tricks that a child might enjoy, shooting household objects – a tap, a pair of glasses – in fragments, or in extreme close-up, as a child might experience them. Morell is best known for his innovative use of the centuries-old device of the *camera obscura*, used here to project a spectacular upside-down view of Brookline on to a wall of Brady's room. The image of Brady and his sister lying on a child's sketch of a house – 'in the shadow of our house' – is a joke that they probably enjoyed but, to adult eyes, seems curiously sad. Is the 'shadow' metaphoric as well as literal?

Nicholas Nixon
b Detroit, Michigan, USA, 1947

For many years Nicholas Nixon has been making affectionate, playful, apparently informal 'snapshots' of his wife Bebe and children Sam and Clementine. It was after the birth of his second child, Clementine, that he became really 'fascinated' – 'there was something about her that moved me tremendously.' He works with a 10 x 8 view camera, so the touchingly intimate shots of his family have in fact been carefully choreographed, or even staged. And so has his most intriguing project. Each year since 1975, Nixon takes a formal photograph of his wife and her three sisters standing together in the same order. His camera hints at the complicated and changing feelings that bind the family of sisters together and sometimes, perhaps, divide them. But the true, darker subject of *The Brown Sisters* is the way in which time affects those we love. The series has acquired depth – and become very moving – as the years have passed, and the fresh young faces have slowly changed, looking, imperceptibly at first, but inevitably, lined and tired. And perhaps more beautiful.

Bernard Plossu
b Dalat, Vietnam, 1945

Bernard Plossu is best known for the photographs taken on his travels in the more desolate regions of the world, gathered in his highly regarded book, *The African Desert* (1987). Like most photographers, however, he feels compelled to return to the people who mean home. The charming shot of his wife Françoise and their children walking along the road at night during a festival in Almeria, Spain, resembles the family snapshots, simple but full of feeling, that any of us might take; that, indeed, was the effect Plossu wanted. He rejects 'professional' photographic tricks and fancy cameras, which might get in the way of the simple but profound images of family life he wants to convey. In one shot, Françoise, smoking, looks at her husband with the patient self-confidence of a woman familiar with, and unfazed by, his lens. His most tenderly intimate image – a tribute to the trust between them – shows Françoise with the light outlining her face as she sleeps.

Paul Reas
b Bradford, UK, 1955

Ten years ago, when commissioned to do some work for the exhibition 'Who's Looking At The Family' (Barbican Art Gallery, London, 1994), Paul Reas began a series that he called *Portrait of an Invisible Man* (1993–2003) which set out to investigate his unhappy relationship with his father. He commented at the time that he remembered 'a man of secrets and suspicion. A detached man. A man of greed and sarcasm …' The photographs recreate, very powerfully, the point of view of an anxious, angry child trying to understand his father's detachment. But recently Reas went back to his childhood home and, this time refusing to be intimidated by the silence, persuaded his father to talk. Gradually the unexpected story emerged of his father's terrible war experiences: he had joined up at fifteen, was taken prisoner and transported to Auschwitz. 'From the fading memory of a man who had locked things up for so long' Reas made a film; and, with greater understanding, his own pain and resentment slowly disappeared.

Sophie Ristelhueber
b Paris, France, 1949

Over the last twenty years, Sophie Ristelhueber has become known for her powerful images of the devastation left by war. She has photographed in Beirut, Kuwait and Iraq, and on the sites of older battles such as Waterloo – all 'territories that have been worn down by man'. Her images are oblique, allusive and disconcerting. Recently, Ristelhueber has been considering her own past. The series *Vulaines* (1989) drew on her childhood memories, pairing old black-and-white photographs, interiors seen through a child's eyes, with contemporary colour images. She was anxious to avoid any nostalgic sentimentality, but this mysterious and haunting photograph from *Les Barricades Mystérieuses* (1995), the sequel to *Vulaines*, is more romantic than usual. Like much of her work, it seems to allude to memory, traces left from the past, the way the simplest objects can preserve, and sometimes lose, meaning and value with the passing of time.

George Rodger
b Cheshire, UK, 1908. d Kent, UK, 1995

George Rodger – writer, photographer and co-founder of Magnum – was a great traveller, perhaps best known for his work in Africa. He insisted on being called a photographer and not an 'artist', and wrote to his son Jonathan, who hoped to follow in his father's footsteps, that he would achieve nothing 'by jetflighting from one fleshpot to another wearing an expensive camera round your neck'. The boy should acquire an old car, guaranteed to break down, and 'see what you end up with'. And, above all, he must discard any preconceptions: 'it is through the viewfinder that you establish the link between reality and your own interpretation of it.' George Rodger and his wife Jinx took their three children travelling abroad every summer. They camped, bought food at local markets and avoided tourist attractions, their father simply equipping the children with maps and local information. This photograph of their son Peter in the Sahara bears touching witness to his methods.

Willy Ronis
b Paris, France, 1910

The celebrated French photographer Willy Ronis took this picture one Sunday in 1952, not far from Paris. His wife Marie-Anne and her young son Vincent asked him to stop the car and take a photograph of them having a snowball fight. He acknowledges the impulse – in himself as in everyone else – to take family photographs that capture those we love, that preserve them in memory; and here, he says, there is no difference between an amateur and professional photographer. But this time, he remarked later, he was reluctant. It was a dull day, and the whiteness made the landscape look bleak and sad. However, there was a hedge along the edge of the field, and taking his camera behind its bare branches he waited for the right moment. He took a number of pictures; this one, reproduced most often, is his own favourite because, he believes, 'it is a photograph of happiness'.

Ferdinando Scianna
b Bagheria, Sicily, 1946

Ferdinando Scianna lives in Milan but is Sicilian born and bred. He has made an extensive photographic record of his birthplace. In his best-known book, *Les Siciliens* (1977), his portraits, street scenes and landscapes communicate his deep feeling for a place that, for all its traditional religious culture, is coming to terms with the modern world. The photographs here – they could be of the cast of an Italian neo-realist movie – cover four generations of his family. The series makes telling points about both change and continuity. Whether he is working in black and white or colour, his family pride, his clear-eyed affection and his respect for tradition are obvious. The series moves from a traditional formality found in the portrait of his grandparents in their parlour on their fiftieth wedding anniversary to the casual but moving photograph of his father proudly holding his own small daughter.

Nigel Shafran
b London, UK, 1964

Much of Nigel Shafran's work seems to belong to the great tradition, one more highly developed in painting than in photography, of still life. He concentrates on low-key, undramatic details of everyday domestic life, and invites us to look at them afresh, to discover significance, a reassuring sense of continuity, and often surprising beauty. *Washing Up* (2000) comprised more than 170 images of the dishes washed and left to dry in his own and others' kitchens; since then, he has made a series inside the charity shops that spring up in most high streets – objects discarded and perhaps about to be recycled – and another of street markets. These formally composed black-and-white photographs of his father's 'office', apparently used as a dumping ground for discarded domestic objects, are unexpectedly poignant; the colour photograph of a storage wall in *Jill and Terry's garage* has the formal structure and subtle colours of an abstract painting.

George Albert Newton Smith
b South Bank, Middlesbrough, UK, 1916.
d South Bank, Middlesbrough, UK, 1989

In 1938, Albert Smith, a young steelworker from South Bank near Middlesbrough, bought a Brownie box camera. During the next twenty years, all of Albert's pictures without exception portrayed either his family or friends – a celebration of life, especially during the years of love he

was soon to share with his wife and three growing children. Sadly his photographs of everyday domestic life stopped as those special years came to a bitter end. By order of County Court, a broken man was given 48 hours to leave his home for good. During the trauma of those final days, his young son Graham salvaged a shoebox full of scratched negatives from the bin, every one a memory of better days. That a man whose work and class was routed deep in the heavy industry of ironmaking wanted to take such pictures, including self portraits, was exceptional. Walker Evans once said that the snapshot represents the essence of photography; Graham Smith – who by chance grew up to become a distinguished photographer himself – has given these private snapshots new life and meaning by making them public.

Howard Sooley
b Balby, Doncaster, UK, 1963

Howard Sooley's sense of himself, he says, is connected with the landscape in which he grew up; his deepest memories are of places, as much as of people. But places, too, show the effects of time. His mother's home village, where he once played with his grandmother, is now a ruin: 'thistles grow where my granny sat in the back kitchen'. Fields have been built over and old houses boarded up or pulled down. Sooley began making a photographic record, both in austere black and white, and in colour, of what remains. The Doncaster house where his father lived as a child (he has a photograph of his parents in its front garden on their wedding day); the local butcher's shop, now boarded up; the greengrocers, this at least still a general store. Sooley takes pleasure in the inevitability of change, and that heightens his need to record this place – 'the background to the story of who I am' – before it becomes a memory, a fiction.

Edward Steichen
b Luxembourg, 1879. d West Redding, Connecticut, USA, 1973

What does a photograph say? What does this self-portrait of Edward Steichen with his sister Lilian, both on the threshold of their lives, tell us about them? The photograph unwittingly hints at a difference between men and women, or at least between this man and this woman. Steichen himself, looking out confidently with practised charm, from beneath the brim of his fashionable hat, almost flirts with his own camera. He went on to become a grand old man of American photography. Lilian faces the lens uncertainly, perhaps sadly, without seeming to pose. Is that something momentary, a photographic accident? Or has the camera caught a lasting truth about their relationship? Lilian married Carl Sandburg, who in 1955 wrote the prologue to Steichen's enormously successful – if sentimental – and controversial 'Family of Man' exhibition. But it is the hint of ambiguity in the relationship between the youthful pair that makes this image so fascinating, so apparently modern.

Alfred Stieglitz
b Hoboken, New Jersey, USA, 1864. d New York, USA, 1946

Alfred Stieglitz believed that a true portrait was not just a single image: he dreamed of photographing a child at birth and continuing every day through a lifetime, creating a 'photographic diary'. He was married with children when he fell in love with Georgia O'Keeffe and, over a period of twenty-three years, he took more than 300 photographs of her. O'Keeffe was an independent and uninhibited artist herself, and the series bears witness to a complex, changing, sometimes stormy relationship. It is clear that she is his collaborator, no passive model; she insisted that he see her,

not invent her. Together, the pair created the greatest love poem in all photography. There are portraits, sensual nudes, exquisite close-ups of hands, feet and breasts; and Stieglitz movingly catches the effects of time, as the fresh-faced girl matures and ages. Sixty years on, after his death, Georgia O'Keeffe looked at the images and remarked, sadly, 'I wonder who that person is'.

Paul Strand
b New York, New York, USA, 1890. d Orgeval, nr Paris, France, 1976

Paul Strand, one of the twentieth-century's greatest photographers, was a friend and a rival of Alfred Stieglitz. When he met Rebecca Salsbury in New York in 1920 he hoped to out-do Stieglitz's studies of Georgia O'Keeffe. Rebecca was twenty-nine, restless and depressed. The pair married, and she became Strand's favourite model, sometimes a crisply critical one. 'You seemed to want to identify me with a tree', she once complained, 'and I wasn't feeling that'. Modelling for Strand could prove difficult. He worked with an 10 x 8 view camera, and the long exposures meant that she sometimes sat with her head clamped in an iron support. By the time the couple separated in 1932, Strand had taken more than a hundred photographs capturing her strong sculptured face in tight close-up. It was because he photographed her over such a long period, Strand believed, that he could achieve a powerful blend of form and feeling.

Larry Sultan
b Brooklyn, New York, USA, 1946

In 1983, Larry Sultan began to spend more time with his ageing parents. Spurred on by a sense of urgency, a feeling that time was running out fast, he asked endless questions, pondered over family documents and photographs, and took new pictures of his parents, separately and together. He recorded, with sympathetic humour, his father practising his golf swing in the living room; standing, bony and fragile, by the swimming pool; or talking to his wife through the kitchen window. The house is captured in a series of vivid close-ups – his father's chaotic desk, the hectic green curtains in the living room, the Thanksgiving turkey ready for the oven. Sultan admits that the project proved unexpectedly painful; it became, in part, an exercise in self-discovery. He becomes increasingly aware of his parents' vulnerability and perhaps of his own as well.

Paddy Summerfield
b Derby, UK, 1947

For years Paddy Summerfield has been photographing his parents, always looking down from the upstairs window of the north Oxford house they share, formally framing them on the lawn below, sometimes singly, sometimes together. The images seem both intimate and distant; detachment is paired with loving concern. Summerfield mounted the photographs in albums, which he presented to his parents; he describes his series as 'a photographic meditation, an extended love letter, a journal of created memories'. The couple, whom he photographed every day for the last five years of their life together, are sometimes absorbed in garden work, sometimes simply holding hands or walking arm in arm. The whole project takes on poignancy and urgency from Summerfield's implicit recognition that his time with them must be short. His mother was already suffering from Alzheimer's disease but even that, Summerfield says, could not break 'the loving bond of their sixty years of marriage'.

Juergen Teller
b Erlangen, Germany, 1964

Juergen Teller, a well-known fashion photographer, has recently concentrated on personal projects, collected in his book *Märchenstüberl* (2003) whose title translates, literally, as 'fairytale den'. It juxtaposes self-portraits, often nude, with images of his native Germany. He also includes shots of models and other fashion-world celebrities, looking dishevelled and undernourished: what has been labelled 'grunge' photography. In an attempt to examine and confront his own past, particularly his difficult relationship with his father, Teller has consistently photographed his family. An image of his father's table is, he says, about absence; another shows his mother at his father's grave. When Teller met Venetia, he began photographing her, and later their daughter. This picture in which the figures are set against a background of densely tangled vegetation, seems oddly remote. Venetia, strong and self-contained, has her hands cradled protectively around her baby's head. The child hangs heavily in the sling, and Venetia seems to stare at his camera coolly, even defensively.

Larry Towell
b Ontario, Canada, 1953

Larry Towell is a much-travelled photographer who is deeply engaged with human rights and has worked as far afield as India, El Salvador, Gaza and the West Bank. He is interested in people's relationship to their land, and in what happens when they are dispossessed, losing not only their livelihoods but their identities. Towell was brought up in a small farming community in Ontario and his more personal work is informed by love of the place where he belongs and feels rooted. He and his wife Ann bought a farm there, and much of his work, when at home, has been about his Mennonite neighbours. These affectionate, apparently casual photographs of his immediate family also offer an intriguing insight into the connections between a place and the people who live there.

James VanDerZee
b Lenox, Massachusetts, USA, 1886. d Washington, DC, USA, 1983

James VanDerZee was a commercial photographer best known for his studio portraits, taken between the wars, of Harlem's bourgeoisie and its newly successful actors, artists and singers. He grew up in a New England hamlet, where his family had lived for generations. Working for wealthy summer visitors, they were comfortably off; VanDerZee recalled his childhood as easy and happy. In his early teens he acquired a mail-order camera and, despite working in local resort hotels, found time to experiment and was soon using it confidently. The photograph *Road to Home* captures his feelings about a place he loved; it is already infused with nostalgia, as if he knew that his time there would be short. He and his family, formally posed, impeccably and conventionally dressed, present themselves self-consciously, as images of bourgeois respectability. James VanDerZee himself stands on the left of the men; the group of women includes his mother, and his wife Kate standing behind their daughter.

Edward Weston
b Highland Park, Illinois, USA, 1886. d Carmel, California, USA, 1958

It has been said that Edward Weston photographs rocks as if they were people, and people as if they were rocks. His photographs of women and children – even his exquisitely formal nude studies of his young son Neil for example, are no more or less important than his famous image of a pepper. But his work changed after he met Charis Wilson, who was thirty years younger than himself, early in 1934. She became his partner and favourite model – one of his most sensual images has her rolling naked in sand dunes – and his work became less abstract, more intimate: no more 'bits and pieces', Charis remarked, but 'whole people in real places'. These affectionately informal photographs show his grown sons at ease in a stony landscape: Cole, his arm slung affectionately around his wife; Brett relaxed with his small daughter. An old man photographs youth with more than a hint of wistfulness.

Index

Editor's Acknowledgements

The acknowledgement that comes first is to a piece of writing. Roland Barthes' book *La Chambre Claire* (Camera Lucida, 1980), written in the short time between his mother's death and his own, is a meditation on the nature of photography and a deeply personal work. In searching for the 'true' image of his mother, he is inspired by a photograph of her as a child, and he considers the moment of recognition – at once an encounter with himself and with history – and the very private effect of a photograph on its observer. Photography, as Barthes calls it, is a 'message without a code'; the photograph of his mother as a child seems to harness something at the heart of this unique relationship between photography and one's family.

My greatest expression of gratitude is to the photographers for allowing us to publish this often sensitive and always precious photography, in some cases for the first time; and for their enthusiasm and support and very great individual contribution. With thanks particularly to Richard Schlagman and to Katy Baggott, Béatrice Chauvin, Victoria Clarke, Lise Connellan, Hamish Crooks, Imogen Forster, Sarah Greenough (National Gallery of Art, Washington, DC), Liz Jobey, Sirkka Liisa Konttinen (Side Gallery), Fran Morales, Robin Muir, Simon Parris, Henri Peretz, Amanda Renshaw, Jinx Rodgers, Millie Simpson, Patricia Spencer-Wood, Michael Vere Hunt, Margaret Walters and Mari West.

Picture Credits

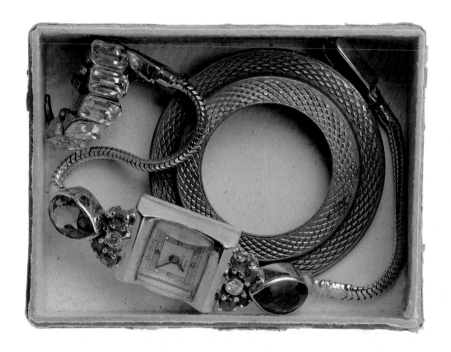

Sivan Lewin photograph from THINGS WORTH KNOWING, 2001